WAKING UP *grey*

Here's What Others Are Saying About

WAKING UP *grey*

"I realized I wasn't stuck in my creativity, but stuck in my spiritual growth. I had false views of my Master. I feel like I have just changed a prescription for eyeglasses. I have a completely different view and relationship in my life with Him than I ever have. He is different than what I knew before. I am different. My Husband and I are more intimate. I am truly thankful that this has found me and that it is such a safe place." —AMY

"We discussed many issues I had been wrestling with. It enlarged my thinking on creativity greatly." —BETSY

"My fellow searchers are a huge blessing to me—I'm moving forward in journaling and drawing due to their courage and encouragement to me. We have shared so much of the heart, they will be 'Artist' friends forever." —NICKY

"I knew that I had some areas of artistic wounding; and *Waking Up Grey* helped me find a place to both create art and experience a safe community of fellow artists. The encouragement, healing and growth have been great blessings in my spiritual and artistic life! Thank you, Jennie, for the timely invitation to walk the creative path with you!" —TORI

"This course has felt like taking a cloth stopper out of a bottle. Little bits of creativity would trickle through but the flow was interrupted. It has also been a means of experiencing God's overwhelming presence through my creative processing. The best part is that I know it's just the beginning. The dam is about to break." —HOLLY

"I never considered a speaker an artist until someone suggested I do *Waking Up Grey*. My creativity went from black to color as I dug deep into the insecurities buried in my heart, and then let them go, with tears, laughter and love. *Waking Up Grey* deeply affected my soul and my business as I allowed myself to crawl out of my self-imposed cocoon." —SANDY

"Jennie reminds us that creativity is a natural expression of our worship. When we know the Creator deeply and beautifully, our creativity is free to soar." —DEBBIE

"*Waking Up Grey* helped me to embrace how God really made me, to be creative. I hadn't allowed myself to cherish the unique ways that He has created me, thinking that those longings were not worthy to be pursued. I am now chasing after opportunities to express myself and discover ways to see and express God's creation. I am also embracing my story more fully now, instead of clinging onto painfulness in my life." —TIFFANY

"*Waking Up Grey* embraces my creativity with a generous invitation to explore and fulfill the essence of who I am. The message and process of seeking my life with creative lenses brings clarity and richness to the mundane and ordinary task of living my life." —SHARON

"I understood for the first time how much we avoid connecting with God, even when we don't realize it. It enabled me to sit in the hard places with God and press into connecting with Him. I realize that if we can press through our resistance to God's presence, we experience an intimacy and vulnerability with Him. If we can make it to that place, I found that it's the place where His creativity is birthed in us." —NIKKI

"Jennie Schut's work offers both the 'nudge' and shoulder of a friend who is meeting God in her journey, inviting us to pause, to look more deeply into how He is beckoning us individually to come to His table and be satisfied with nothing less than His presence. Like few other books or studies, Waking Up Grey has been a hand-penned invitation to invest time exploring the inner recesses of my heart with Jesus. The Lover of My Soul has lightened my load, grieved with me, laughed with me, and danced with me in His great love in ways that have indeed transformed my day-to-day and strengthened me for the battle." —CAROLE

"While effective in its renewal of individual creative LIFE, it also serves to steward the SOUL and friendship in unspeakable ways! —DIANE

"So often we set up camp on lonely, boring islands void of excitement, community, and real, invigorating life. Walking through *Waking Up Grey* with other ladies invited a life raft full of other hurt, healing, and hopeful women to join my journey... the adventure of resting in my Creator's care and expressing HIS goodness!" —BRIANNA

"*Waking Up Grey* has gone light years beyond the idea of creativity for me—it has been incredible therapy and blessing, especially in teaching me how to begin to love myself as God intended. —ANITA

This book gives dignity to each unique story of loss, disappointment and pain. These pages are gentle reminders of a redemptive God.

—**David Thomas**, Therapist and Author, *Wild Things: The Art of Nurturing Boys*

Waking Up Grey: An Exploration of Creative Awakening is all that and more. Jennie Schut has effectively led her students and readers through the discovery of inner expression. After reading *Waking Up Grey*, as an Artist I have been profoundly challenged to give more of myself away. As a Pastor I have been re-introduced to my God as my Creator. What more could one ask for a book to deliver?

—**Scott Roley**, Senior Pastor of Christ Community Church in Franklin, Tn. and Author of *God's Neighborhood*

Jennie Schut has written a deeply wise and beautiful book, full of profound insight into the faith-filled, creative life. *Waking up Grey* is layered and rich, born out of Jennie's own story of artistic awakening. With great respect and care she leads the reader through a process of biblically grounded, creative discovery. *Waking up Grey* will guide you safely through the hills and valleys of your calling to live creatively—don't miss the trip!

—**Andi Ashworth**, Author of *Real Love for Real Life: The Art and Work of Caring*, Co-director of Art House America

Waking Up Grey lays out such a creative and provocative path for self-discovery and the release of our truer selves! It asks all the right questions, evokes all the powerful emotions and imagines all the beauty we so desperately long for. As a therapist, I've seen wonderful transformations in many of my clients who, as an adjunct to our therapeutic work together, now walk the journey described here. Grab a friend, live this book together and hold on for the time of your life!

—**Dr. Bruce McCurdy**, Director of Counseling at Christ Community Church, Franklin Tennessee

WAKING UP
grey

AN EXPLORATION OF CREATIVE AWAKENING

JENNIE SCHUT

NEW YORK

NASHVILLE • MELBOURNE • VANCOUVER

WAKING UP *grey*
AN EXPLORATION OF CREATIVE AWAKENING

Published in New York, New York, by Morgan James Publishing. Morgan James is a trademark of Morgan James, LLC.
www.MorganJamesPublishing.com

The Morgan James Speakers Group can bring authors to your live event. For more information or to book an event visit The Morgan James Speakers Group at www.TheMorganJamesSpeakersGroup.com.

ISBN 978-1-68350-206-7 paperback
ISBN 978-1-68350-208-1 eBook
ISBN 978-1-68350-207-4 hardcover
Library of Congress Control Number: 2016914303

In an effort to support local communities, raise awareness and funds, Morgan James Publishing donates a percentage of all book sales for the life of each book to Habitat for Humanity Peninsula and Greater Williamsburg.

Get involved today! Visit www.MorganJamesBuilds.com

TABLE OF CONTENTS

ACKNOWLEDGEMENTS

This body of work belongs to those who have walked the road with me. It is a product of being surrounded by people who are older and wiser than I am. I have been the recipient of gracious, deep love by my friends, family,mentors and teachers. Thanks to Gabrielle Joyelle Thompson, who first encouraged my exploration. As I explored, I found that many around me were longing for the same adventure. Thanks to Shacina Beard for your hunger that compelled me to begin writing.

The changes in the second edition reflect language and experienceof God that have changed and deepened since Waking Up Grey was first published in 2009. The original format has not changed with the exception of additional space for art journaling. During this process, I participated in a Spiritual Direction Training Program and discovered more writers and thinkers in the contemplative flow. You will find those influences throughout these pages. I met new friends along the way and experienced deepening relationships with old friends, whom I must name here. Thank you Renee Farkas, Marya Elrod, Julia Halford, Cherie Shepherd, Stacy Elliott, Karin Saccardi, Kirsten Howard, Brooke West, Lee Brewster, Lynn Farris, Amanda Blankenship, Pam Jones, Noel Fagan, Sharilyn Grayson, Marilee Tice, and Julie Duncan.

Thanks to the following teachers, mentors, counselors and friends whose impact is found throughout the pages of this book: Nita Andrews, Charlie and Andi Ashworth, Kenny Benge, Staci Brezinka, Anne Ciccoline, John and Renee Farkas, Dede Franz, Karen Grant, Bruce McCurdy, Tricia McDermott, Jennifer Pirecki, Gail Pitt, Scott Roley, Scotty Smith, Mary Thompson, Sharon Thompson, Kevin and Wendy Twit. To Dan Burns who has helped to make this the best possible version. I look to you as dear friends.

This Edition could not have been created without Kirsten Howard, whose brilliant ideas fanned the flame of a 2nd edition. Your creativity continues to blow my mind. The eyes of Dede Franz have been

invaluable to the editing process, not to mention, your heart for this work. Thank youfor making it better, both in context and grammatically. Thank you Karen Anderson, for believing in me and this work!

Thanks to my family and friends who have been so supportive of my expressions of creativity. Thank you, Mom, for being so trusting and open-handed with your story. Thank you Rachel, Ellie, Maggie and Brennyn for cheering me on. I am inspired by your own creative stones.

Worship and gratitude to The Lover of my soul; the same hands that hold all things together extend themselves to me in invitation to the feast. Yes, I come!

GROUP GUIDELINES

These guidelines are given to provide a safe, supportive and nurturing environment to group participants. These guidelines are intended to ensure the success of every participant. Please take great care in adhering to these:

- Remember that trust grows over time. Share only as much as what feels safe for you. Risk sharing more only when you feel safe doing so.
- Be an attentive listener. You can learn much from other people's insights if you will take time to really hear what they are saying.
- We must refrain from the urge to "fix" another. When it strikes you, stop and engage in listening. Most of us want to be heard, not to be fixed.
- Maintain confidences. Remember that anything that is said in the group is considered confidential and must NOT be shared outside the group unless specific permission is given to do so.
- Resist the temptation to talk about others people's stories. We want to hear about you and get to know your narrative rather than your spouse, children, friends, family, etc. Also, guard against discussion of another participant in her absence.
- This is not a therapy group. I am not a professional counselor. The nature of the book certainly brings up things that can go beyond the scope of this class. I strongly encourage professional counseling alongside this course.
- Be sensitive to each participant in order for all to have an equal opportunity for sharing. Remain focused on the material to be covered in the group. Reserve conversations that go beyond the scope of this group for another time.
- Be as honest with yourself and others as you possibly can be.
- Pray for the other members of the group.

(Adapted from David Seamands and Beth Funk's Healing for Damaged Emotions, © 1992)
PERMISSION TO REPRODUCE

INTRODUCTION

WAKING UP GREY is designed to help you reawaken your creativity. "Reawakening" presupposes that something in us has fallen asleep. If you feel out of touch or even dead creatively, this book will help you uncover why and help you to return to the process of creating. You will learn to not merely move forward in your creativity, but Fly Forward; soar, as you are meant to. Creativitywill not rouse from sleep without help. You must fight for it. We will discoverwhat/who told you that your creative self was not valuable. This discovery work will be facilitated through solitude, listening prayer, journal writing and community. As you spend time in the presence of Jesus, with pen and paper in hand, your thinking about creativity will be transformed. Spending time in a supportive community will reinforce this transformation.

You will notice that Waking Up Grey is full of artwork, including paintings, drawings, song lyrics, poetry, and passages of literature. Some are lengthy; some are short. Some are religious; some aren't. Some are works of professional artists; some are not. This was expressly intended. It is important to immerse ourselves in really good art because it sharpens our expressions and aids our flight forward. Everyone is in a different stage in the process, and everyone has different expressions and degrees of ability in creating. Hopefully, you will experience this book within a supportive community that encourages and witnesses the flourishing of each member's emerging creativity.As you wrestle free from the cocoon, your wings may feel unproven. You must learn to extend yourself mercy, as this emergence takes some time. There is a section in each chapter called "Emerging Creativity," which contains works representing others' journeys in the context of supportive communities. They are meant for your encouragement and inspiration along the way. The works of art within these chapters reveal snapshots from the unique stories of their creators. Please see the artwork as an invitation to accept and enjoy the unique journey you are on.

In each chapter, you will also find daily journal exercises called "Questions for Reflection." Daily writing is vital in allowing your creativity to flow and move forward. Setting time aside for writing necessitates moving away from distractions and moving into moments of solitude and rest. Protect your journal time with vigilance! Note also that "Questions for Reflection" serves only as a guide. If your conversation with the Lord goes in a different direction, have freedom in that and allow yourself to deviate. After all, this is a creative process! There are seven questions in the sections, one for each day of the week. You might find some compelling things happening around one question and find that your week is better spent nursing that one question. Or you may only get to two or three questions that week. St. Ignatius says, "Stay where the fruit is." These questions are only suggestions. Stay open to the process and allow God to direct your time with Him.

The last section of each chapter is called "Solitary Perusings." This exercise is to be done in solitude and in silence. Solitude is paramount to your creative discovery. Your time alone with Jesus will be the time when you rediscover over and over how much you are loved and delighted in. Only from that place will you find true creative freedom. This is where you taste the extravagant feast God has set before you—a table upon which your creativity is stirred. "Solitary Perusings" must also be free from distraction and noise. Find a quiet place that is absent of books (other than the Bible), computers, television, music, and any other background noise. Be intentional about making your environment free from distractions.

THE IMPORTANCE OF REST

I have used toil and work as a primary means of seeking God's approval. I thought if I served Him enough, certainly He would gaze at me approvingly and I would earn His favor. My labor became tedious and unpleasant. It wasn't until I allowed myself to rest that I realized that the motivation behind my work was driving my sense of drudgery and discontentment. But in the rest that Jesus freely gives, I found new delight! As you tend to your creativity, my first prayer is that you would find rest. Your rest is important to Jesus, who says, "Come to me, all you who are weary and burdened, and I will give you rest" (Matthew 11:28). Resting in Him helps us find purpose in our creative work. Give yourself permission to cease from your labors and find green pasture in the solitude. It is in the place of rest that we are reminded that God's approval is forever secured! We already have His favor and will never lose it. Our work is a gift, not a means to prove ourselves. In this knowledge, we become unencumbered by preoccupations with God's acceptance and are liberated to exercise the callings He has given us. When we operate from a place of delight rather than duty, we tend to be more in touch with the pleasure that flows from God over us. Wait... listen... do you hear it? Tune your heart... that is God rejoicing over us with LOUD SINGING (Zephaniah 3:17)! As you rest, you will begin to hear that music more often.

CONNECTION TOOLS

Creativity is a spiritual issue. We derive our creative abilities from the One who created us in His image. It astounds me how God created this majesticworld with all sorts of creatures and natural wonders. But then ponder God's crowning glory in fashioning beings that reflect His image: He was not miserlyin apportioning His glory to the world and His people. He wants to share Himself and what makes Him beautiful! When we engage in the creative process,we participate in the mystery of God's beauty. For this reason, listeningprayer is a powerful tool for reconnecting with your creativity. Listening prayer is simply conversing with the Lord. As you bring your creative self before Him in a posture of listening, you will begin to understand the connection between your creative journey and worship.

Listening prayer will be practiced as a combination of writing and solitude. Your journal will be a record of your conversations with Jesus. Through Him you will discover new things. He will bring healing to wounds that hinder creativity. Most of your discoveries will occur as you write, beginning with revelations of how God sees you. As you move further into the book, you will be called "into the Grey" and reclaim dreams, gifts, and talents that may have become obscured. This may involve simultaneous processes of grieving losses and moving into the light and joy of creating once again.

My experience of creative awakening was solitary at first. I learned that discoveries are usually birthed through listening prayer, journaling, and practicingart. However, discoveries also emerged in the context of people and relationships.I always encourage participants to share their creations—whether finished or unfinished—with the group. Once champions for your creative process gather around, you will dare to Fly Forward. Community sharpens us. Community helps us show up. Community fosters baby steps. While the hard work tends to occur in solitude, most of the celebration happens in community.

If the connection tool of community sounds unappealing or even repellent to you, then it may be most appropriate to engage the material on your own for a season. However, I strongly encourage you to revisit the process in a group context, especially if you tend toward isolation. For the long haul, you will need outside support. I have found that creative stories continue unfolding long after the course has ended. Waking Up Grey is a launching pad for the rest of your creative life. Creative community fosters and upholds new growth. As creative expressionists, we are particularly vulnerable to the harshness of the outside world. We need advocates who believe in our work. We do best when we sojourn together.

ENCOURAGEMENTS

Do not be surprised if there comes a time when you want to shelve the process of creative discovery or abandon the journey altogether. Be encouraged! This means you are doing the hard work! It means you are moving through fear or confronting some other challenges. If you start feeling this way, work to discover and name the barriers and press through them. Perhaps the best way to prepare is to anticipate that the process will be hard sometimes. Bring community around you like a warm blanket on a cold winter's night. Call someone. Seek wise counsel. For some, seeking a professional counselor may be necessary. This book is not therapy, but it has the power to stir things up. If this is the case, you may need to set the book aside for a season and seek professional direction.

Finally, I encourage you to be audacious. The valleys along the way make the mountaintops all the more breathtaking. Do not be afraid. When you experience the exhilaration of the mountaintop, your time in the valley brings about unparalleled dignity. May your creativity be a worshipful expression of having entered the sanctuary of the Living God.

God bless your journey!
Jennie Schut

WAKING UP *grey*

Grey lies in bed and envisions the places she wants to go and the things she wants to do. But the visions in her head only lead to disappointment and despair. Her imagination fades and she ceases to dream. She's waiting for something … for someone … to find her, someone to come and arrest her senses. She wants to be captured and enticed by something so beautiful and extraordinary that she cannot help but lose herself in her Captor. She hears His voice saying, "Come and be my bride." "Surely this One couldn't be my alluring lover. He's too preoccupied with my law-keeping. He requires duty, not sensuality, fulfillment and pleasure." Everything she attempts mingles into grey.

In the distance, barely visible, Grey sees a beautiful table set for two. She hears a Voice inviting her to a grand feast, but it is barely audible, for the grey has become like a vapor too thick for any sound to cut through. But there's just enough to spark a faint sensation of hope. Could this be true? Could she believe that this invitation has her name on it? The question she dares to ask sends a ripple of red across the skyline.

one

A NEW HIDING PLACE

The Call to a New Hiding Place

You have been invited. Jesus is inviting you to uncover, discover and recover your beautiful calling of creativity. He is inviting you to come out of hiding. Why do we prefer our fig leaves over the glorious robe He has given us to wear? The King is inviting us to take our rightful place in His kingdom. In the weeks to come, you will spend time with Jesus in solitude. Through various tools and exercises, you will discover what has been so compelling about staying hidden. You will learn to emerge from hiding as Jesus reveals how He has wired you to create. He has set this time aside and ordained it. Your senses will be heightened; your ears will recognize the sound of His voice. Your eyes will see that God is on the move, inviting us to be intoxicated by His beauty as it breaks into our brokenness, to the end that you and I will be different, more fully alive and present to our lives.

1

We must first understand and shift our thinking about creativity. Many people of faith today do not feel the freedom or calling to be creative. To many, it feels unnecessary, or extravagant, or somehow contradicts responsible Christian living. This thinking is erroneous because God is not miserly. To be a Christian is to imitate the character and mind of Christ. My dear friend and mentor Andi Ashworth, in her book Real Love for Real Life, describes the character of God in this way: "We serve a God of creativity, sacrifice, and extravagance. We, too, are called to reflect these characteristics..."[1]

The following is a list of principles—the **Creative Basics**, if you will—that guide the concepts in this book. This is God's story woven throughout all of scripture... a story that is still being told today.

creative basics

We have been made in the image of God; into His likeness.

With the Fall, there was a terrible distortion and disintegration
of ourselves as image-bearers of God, but our true nature
as image-bearers remains.

Jesus, who rescued us, is even now in the process of
restoring His image in us.

Part of His restoration includes our aesthetic, creative sense.

God reveals Himself as we tend to the creative process
in ourselves.

We bring pleasure to God when we worship through the
creative process.

The world needs truth, beauty and goodness.
He delights when we create to bring about
more of these within the grand narrative.

Solitude, silence and listening promote worshipful creativity.

Creativity is a stroll, a long walk with Jesus.

When we gaze upon the beauty of God,
our art tends to tell a story.

Our creative process is a natural outpouring
of having been with the Creator.

He has ordained us to be creative and champions our work.

Call *forth*
what you
do *well*
and
name it.
You will
find
you have
been
creative
all along and
just need
to *declare it*
out loud.

We will come back to these. Make a copy, embellish it, and hang it somewhere in plain view. In order to experience freedom, you must believe that you are a character in the grandest story ever told! When your thinking shifts into the setting, plot, and characters within this huge narrative—eyes focused on the Master Storyteller—suddenly your capacity to create enlarges. The depth and vastness of His narrative captures your creative mind and imagination and brings life into the page, canvas, dance floor, strings, etc. You have been with the King and have believed what He has told you.

One challenge we must face is how we define creativity. Creativity is bringing order. When we bring order to something, we are offering up creative worship. When I paint or draw or write, there is a "working out" or bringing order to my emotional life, my worldview, my attitudes, my intellect as well as my creative ideas. If you are one who has never considered yourself to be very creative, sometimes what we really need is to have it called forth. There is a school of thought that we are either left-brained or right-brained people. While there is definitely a dominant side in each of us, we all have the capacity to use both hemispheres. If you have thought of yourself as a left-brained person (structured, organized, orderly, administrative, analytical), consider this: An extremely well-organized closet, for instance, can be a work of art. It brings beauty and order to an otherwise chaotic, cluttered space. It takes great thought and attention to bring beauty into neglected places. It requires creative energy. You have the capacity for making things. If you feel you are deficient in right brain activity, it is time to tap into that side and explore the possibilities. I love how Anthony Hoekema amplifies the ways we can express our creativity! ...by [reflecting] the image of God in the broader or structural sense we mean the entire endowment of gifts and capacities that enable man to function as he should in his various relationships and callings."[2] Call forth what you do well and name it. You will find you have been creative all along and just need to declare it out loud.

Art forms are abundant. Listening with curiosity is an art form. Something as simple as welcoming someone unexpectedly into your home requires creativity. Transforming leftover mashed potatoes into shepherd's pie takes thoughtfulness

and creativity. Be on the lookout for the ways creativity is already present. Name what is already there and let it lead you to further exploration. What creative outlets do you already say "yes" to? What do you say "no" to? Pay close attention to this.

To be human is to create. Because we are designed in this way, creativity has profound meaning to God and to those who are exposed to our creative work. Whether it is creating a beautiful home as the backdrop for family gatherings and memories or rendering paint on canvas, whatever creative calling God has given you must be called out of hiding and named. Exploring how we fit uniquely into God's creation story frees us to uncover our creative wounds, find healing, and move forward in telling our individual creative stories!

The Already of God's Story

It is important as you begin this process to not merely know, but to be alive to the fact that you are the beloved. We are beautiful to the Father. In Numbers 24:1-9, it says the following: "When Balaam saw that it pleased the Lord to bless Israel, he did not go, as at other times, to look for omens, but set his face toward the wilderness. And Balaam lifted up his eyes and saw Israel camping tribe by tribe. And the Spirit of God came upon him, and he took up his discourse and said, 'The oracle of Balaam the son of Beor, the oracle of the man whose eye is opened, the oracle of him who hears the words of God, who sees the vision of the Almighty, falling down with his eyes uncovered. How lovely are your tents, O Jacob, your encampments, O Israel! Like palm groves that stretch afar, like gardens beside a river, like aloes that the Lord has planted, like cedar trees beside the waters. Water shall flow from his buckets, and his seed shall be in many waters; his king shall be higher than Agag, and his kingdom shall be exalted." This description, given by an enemy of God, is an intricate description of the Israelites, what God sees as He gazes upon His loved ones. What poetry! How fierce is His love for me, for you! Let's learn together how to walk in the confident knowledge that, because we are His, we give Him great pleasure. His delight gives us freedom to worship through different art forms. When we paint,

yes

no

write, sing, frame the snapshot, we are dancing with Jesus. He delights not only in the offering, but also in your courage and faith to engage in creative worship.

Hide and Seek

God will always send us to places that require faith. Exploring our creativity requires that we exercise that faith muscle. At times, our response to the challenge of flying forward will not be that of faith, but a game of hide-and-seek with God. Cynicism speaks into our shame of being naked, insinuates that we already know how the world works, and displaces hope. Richard Rohr, in Everything Belongs, writes, "If contemplation teaches us to see an enchanted world, cynicism is afraid there is nothing there."[3] Our hearts, because of shame and fear, drive us to go into hiding. We hide from ourselves, others and especially God. In our isolation, we become elusive. We hide behind our favorite mask: that glittering image of religiosity and morality, or autonomous self expression that is "liberated" from social and cultural expectations. However, our false, inauthentic self emerges; it comes out of the fear that has cast its shadow over our yet-again-incarcerated hearts. We refuse to be found.

What would happen if we let God find us? He has come looking for us. We can't evade Him forever. This game of hide-and-seek started back in the garden after the Fall. "And they heard the sound of the Lord God walking in the garden in the cool of the day, and the man and his wife hid themselves from the presence of the Lord God among the trees of the garden. But the Lord God called to the man and said to him, 'Where are you?' And he said, 'I heard the sound of you in the garden, and I was afraid because I was naked, and I hid myself'" (Genesis 3:8-10). We are naked before God. He is not afraid of our nakedness as we are. Enduring the gaze of God in our nakedness requires not only faith, but also a relinquishment, a surrender. We must relinquish our cynicism, our desire to shrink away and hide, and give Him our shame, fear and control. The courage to surrender comes from the Spirit of God. Maybe this is what His strength perfected in weakness means: our surrender brings us into a new place of hiding, hidden with Christ in God. It would be appropriate to

hide. We have always needed a place to hide, from the time when we were small children. Back then, we needed a place that was safe from all the big, terrifying monsters under the bed. Now, we need a safe place from all the big, terrifying monsters roaring in our own hearts. Back then, the place to hide out was in a daddy's embrace. Now, the place to hide out is still the Father's embrace, but we've chosen other hiding places.

Hiding in God is something that is strung all throughout Scripture. God is referred to with such names as Refuge, Hiding Place, Fortress, Shelter. Do you know that it is okay to feel the need to hide? Don't interpret your strong desire to stay hidden as something that is cowardice, sheepish, foolish or bad. He understands our need for refuge and has made provision for it. The question we need to ask is, "Where are we hiding?" Where we hide has strong creative implications. If you are hiding behind security for fear of uncertainty, you won't take any sort of creative risks. If you are hiding in God, who has given you a calling to create (which He has because you're human), then freedom comes to exercise those callings with pleasure and joy. This assurance only comes from being in the Fortress of God. This kind of freedom is not found in any other hiding place we choose.

It was a Sunday morning much like any other for my husband and me. This particular Sunday, we'd done a pretty good job of tearing one another down. I could say of my own heart that I was bowing down to the idol of self-preservation and the asherah of superiority, tearing him down in my mind. But even amidst the murder in my heart, there were fleshy parts absorbing the truth and beauty of God. As we sat in the middle of the great sea that is our church family, it became a very different sort of morning. As I sang words that I longed to be true and hoped my heart would follow, the vision came. I closed my eyes, whispered to God, and asked Him to show up in my brokenness and define me. In my mind's eye came a courageous, beautiful woman strolling my way. She had a confident beauty all her own. I was drawn to her. As she walked away, she turned her head; and with twinkling eyes and a smile playing on her lips, she disappeared from my vision. Then, somewhere in the chamber of my heart where the Holy Spirit

resides and speaks words of truth, her identity was revealed. "That is you, my sweet daughter. She is what I see when I look at you." That morning began a new epoch in my story and I share it because it changed everything. I caught a vision of what it means to be someone deeply cherished by God.

Being a daughter of God is a remarkable dichotomy. On one hand, when God sees me, He sees His Son—and the perfect life of Jesus, lived on my behalf and counted to me as my perfect life, which I could never attain. This, in and of itself, is an unfathomable gift. But add to that the fact that God intended a particular creation when He formed each human being in his or her mother's womb. However marred and marked I am by the Fall, I am an image bearer of God and I represent a unique individual with a distinct appearance, personality, gifts—everything that makes me who I am. We don't lose ourselves to formless ambiguity when we are hidden with Christ in God. In this vision, I saw my distinctiveness. I saw the distinctiveness of all creation. God sees the mark of His Son on me, but He also sees me: the me that was intended and whom He is working on even now to regenerate! The writer of Colossians puts it this way: "… and [you] have put on the new self, which is being renewed in knowledge in the image of its Creator" (3:10). When we choose to hide in God, that "creation" or "new self" is reinforced, not lost. We become more in touch with our "self" than in any other place we may run to. He is able to tell us who we are and our identities become stronger in His presence as He reveals Himself as "Creator."

Hiding behind knowledge, affluence, works, or some sparkling image becomes like hiding in a dilapidated cardboard box. When we come to the knowledge that God sees beauty in us, because of His Son, we are liberated to do courageous things! Look at Colossians 3:3-4. "For you have died, and your life is hidden with Christ in God. When Christ who is your life appears, then you also will appear with him in glory." God understood that after death arrived, man's first instinct would be to hide. We are people that are afraid; afraid of God, afraid of what we've done, afraid of the dark. God knows this and His answer is Jesus. Have you ever seen a child hiding behind her mother when a stranger comes along? The child clutches so tightly that she disappears into a secret pocket

somewhere. Colossians 3:3-4 allows for our need to be protected. Our lives are hidden with Christ in God! What appears is Jesus. This does not mean we are absent of personality or essence; rather, our persona is tied to Jesus. We do not appear autonomous from Jesus, ever. When Christ, who is your life appears, then you also will appear; this is the promise we find in that passage. Because we belong to Jesus, we have a proper hiding place. As we hide in Him, our truest self emerges, comes out into the world. Miraculously, in hiding, we emerge more true and beautiful.

When we begin to understand how God sees us, we are set free to pursue our callings. The vision of the confident beauty God gave me served as a pivotal point in my life of faith and creativity. It set me off on a wild and risky path that has led to phenomenal creative freedom. Since that vision, I have taken classes to learn how to draw and paint. I have taken trips to Peru, New York City and Italy to teach and learn about God's creative heart and beauty He disperses through His world. I returned to school to learn about art and earn an art degree. I have been writing, teaching, speaking. The list goes on. The journey is filled with wild delight and laughter and fraught with anxiety. The road to a life of creativity requires a courage that doesn't come from within one's self, but from God. In order to make movement in our creative lives, this shift in identity must happen. You matter in God's narrative and so does your work. Believing this liberates us to walk into the places God is leading us.

One of the clearest pictures of God's heart is the parable of the Prodigal Son in Luke 15: 11-32. "And he said, 'There was a man who had two sons. And the younger of them said to his father, 'Father, give me the share of property that is coming to me.' And he divided his property between them. Not many days later, the younger son gathered all he had and took a journey into a far country, and there he squandered his property in reckless living. And when he had spent everything, a severe famine arose in that country, and he began to be in need. So he went and hired himself out to one of the citizens of that country, who sent him into his fields to feed pigs. And he was longing to be fed with the pods that the pigs ate, and no one gave him anything. But when he came to himself, he

said, 'How many of my father's hired servants have more than enough bread, but I perish here with hunger! I will arise and go to my father, and I will say to him, 'Father, I have sinned against heaven and before you. I am no longer worthy to be called your son. Treat me as one of your hired servants.' And he arose and came to his father. But while he was still a long way off, his father saw him and felt compassion, and ran and embraced him and kissed him. And the son said to him, 'Father, I have sinned against heaven and before you. I am no longer worthy to be called your son.' But the father said to his servants, 'Bring quickly the best robe, and put it on him, and put a ring on his hand, and shoes on his feet. And bring the fattened calf and kill it, and let us eat and celebrate. For this my son was dead, and is alive again; he was lost, and is found.' And they began to celebrate. Now his older son was in the field, and as he came and drew near to the house, he heard music and dancing. And he called one of the servants and asked what these things meant. And he said to him, 'Your brother has come, and you father has killed the fattened calf, because he has received him back safe and sound.' But he was angry and refused to go in. His father came out and entreated him, but he answered his father, 'Look, these many years I have served you, and I never disobeyed your command, yet you never gave me a young goat that I might celebrate with my friends. But when this son of yours came, who has devoured your property with prostitutes, you killed the fattened calf for him!' And he said to him, 'Son, you are always with me, and all that is mine is yours. It was fitting to celebrate and be glad, for this your brother was dead, and is alive; he was lost, and is found.'"

The words of the father are so remarkable–to both of his sons. If you'll notice, the father went out to each of his sons. This is where trust comes in. A song written by Dave Matthews poses this question: "Am I supposed to take it on myself? To get out of this place?" The song speaks of a woman whose sense of lostness was overwhelmingly acute. The question is a deep groping; a longing for the answer to be "no." Can you hear in that question the burning longing for a rescuer? The question sounds more like, "Who is going to save me?" The good news in our story, friends, is that there is a rescuer who comes out to us.

Taking it on ourselves to get out of dark places quickly turns sour. When we find ourselves in this place, but ready to be delivered, our trust must be porous enough to receive the Rescuer that has come! We must remember that God is always desiring more love and life for us and that He makes provisions for such. Gratitude can help us more toward those provisions with trust that drops down into soul space.

Here are some thoughts from Henri Nouwen on the elder brother:

"Here I see how lost the elder son is. He has become a foreigner in his own house. True communion is gone. Every relationship is pervaded by the darkness. To be afraid or to show disdain, to suffer submission or to enforce control, to be an oppressor or to be a victim: these have become the choices for one outside of the light. Sins cannot be confessed, forgiveness cannot be received, the mutuality of love cannot exist. True communion has become impossible. Everything becomes suspect, self-conscious, calculated, and full of second-guessing. There is no longer any trust. Each little move calls for a countermove; each little remark begs for analysis; the smallest gesture has to be evaluated. This is the pathology of the darkness.

"Is there a way out? I don't think there is—at least not on my side. It often seems that the more I try to disentangle myself from the darkness, the darker it becomes. I need light, but that light has to conquer my darkness, and that I cannot bring about myself. I cannot forgive myself. I cannot make myself feel loved. By myself I cannot leave the land of my anger. I cannot bring myself home nor can I create communion on my own. I can desire it, hope for it, wait for it, yes, pray for it. But my true freedom I cannot fabricate for myself. That must be given to me. I am lost. I must be found and brought home by the shepherd who goes out to me.

"Although God himself runs out to us to find us and bring us home, we must not only recognize that we are lost, but also be prepared to be

found and brought home. How? We can allow ourselves to be found by God and healed by his love through the concrete and daily practice of trust and gratitude. Trust and gratitude are the disciplines for the conversion of the elder son. Without trust, I cannot let myself be found. Trust is that deep inner conviction that the Father wants me home. As long as I doubt that I am worth finding and put myself down as less loved than my younger brothers and sisters, I cannot be found. I have to keep saying to myself, 'God is looking for you. He will go anywhere to find you. He loves you, he wants you home, he cannot rest unless he has you with him.'

"There is a very strong, dark voice in me that says the opposite: 'God isn't really interested in me, he prefers the repentant sinner who comes home after his wild escapades. He doesn't pay attention to me who has never left the house. He takes me for granted. I am not his favorite son. I don't expect him to give me what I really want.'

"At times this dark voice is so strong that I need enormous spiritual energy to trust that the Father wants me home as much as he does the younger son. It requires a real discipline to step over my chronic complaint and to think, speak, and act with the conviction that I am being sought and will be found. Without such discipline, I become prey to self-perpetuating hopelessness.

"By telling myself that I am not important enough to be found, I amplify my self-complaint until I have become totally deaf to the voice calling for me. At some point, I must totally disown my self-rejecting voice and claim the truth that God does indeed want to embrace me as much as he does my wayward brothers and sisters. To prevail, this trust has to be even deeper than the sense of lostness. Jesus expresses its radicalness when he says: 'Everything you ask and pray for, trust that you have it already, and it will be yours.' Living this radical trust will open the way for God to realize my deepest desire."[4]

We need to reorient our hiding places today. We have attempted to hide from God, but by the cross He declares that we have been hidden with Christ in God! We can still hide, but today we hide

in God rather than from Him.

SOLITARY PERUSINGS

Find a quiet, solitary place where you won't be interrupted. Bring nothing with you: no television, no book, no music. Just bring yourself and Jesus. This is VERY difficult. You'll probably meet with resistance. That is OK! Pray through it; ask Jesus why you are resistant. Work through it until your arguments and complaints settle. It may take a good half hour before the noise and movement and bustle subside. Let the room fill up with the presence of Jesus and just "be" together. Take a long, hard look at Jesus. Talk to Him, if you want. Let Him talk to you. Let the solitude a^nd the friend that Jesus is fill your nostrils, your eyes, your ears, your heart and soul! After you have spent time in silence, proceed to make an invitation. Make it out of whatever materials you can find. Or, you can play and shop for fun art supplies.

Your invitation should answer these questions:

Lord, how are you inviting me into a more profound creative journey?
How would it look different to be hiding in You?

This is an invitation from God to you. What would it say? How would it look? HAVE FUN!!

QUESTIONS FOR REFLECTION

Day 1: How does your view of creativity need to expand?

Day 2: Where are some places that you like to hide out that are not in God?

Day 3: What does it mean to you that Jesus has called you the beloved?

Day 4: Which son do you identify most with in "The Prodigal Son"? Why? What is the Father's response to you today as a son or daughter?

Day 5: How would believing the "Creative Basics" on page two invite you to reorient your hiding?

Day 6: How do you identify with Grey? What struck you about her?

Day 7: How does God see you in relation to your own Grey story?

WAKING UP *grey*

The crisp air of autumn seemed to dissipate the greyness clouding her vision. This spark of hope, this shimmer of faint glory that cast itself down with the promise of color brought a hint of gleefulness to her heart. Incredulous at the thought of color and sight and delight, she could smell everything like it was the first time she'd ever lived through an autumn. How she longed to smell apple spice pie or the aroma of freshly hewn jack-o-lanterns, faces glowing in the heat of candlelight. The crisp fall leaves brought her back to a different time as a little girl. Jumping in the crisp, dry piles of leaves, she recalled tunneling through the enormous mounds of leaves which always clung to her clothes and hair, just wanting one more moment of frolic before descending to the ground to be buried under winter's chill. That year she took particular notice of the leaves. They were so beautiful; colorful, yet parched. Each aged line told a story. She wanted to make them last somehow. So she took her finest picks, placed them under paper, and rubbed crayons over the top. Every line and vein and shape was captured in brilliant colors. She was astonished to capture the essence of each leaf before retiring them to the soil. "Leaves," she thought, jolting herself back to the present. "He has always spoken to me through leaves." With excitement, she felt hopeful. He had come for her, even through the grey. The hope that He was listening was intersecting with the spaces where she had already been heard.

Hope was kindled for the mere fact that she now knew that He must come and get her from this place and she must wait for Him to come. She knew at that moment that she wasn't meant to take it upon herself to get out of this place. Hours later, she found herself painting one single leaf on a piece of canvas… It was a rich, warm, gold tone with grey and purple and some orange. The table seemed to inch nearer and it seemed to have more color…

two

THE REDEMPTION NARRATIVE

Echoes of Eden

Memories of a place of beauty and goodness are written within all of us. Even those who claim no Divine allegiance remember the narrative, whether they know it or not. Read Numbers 24:17-19. "I see Him, but not now; I behold him, but not near: a star shall come out of Jacob, and a scepter shall rise out of Israel; it shall crush the forehead of Moab and break down all the sons of Sheth. Edom shall be dispossessed; Seir also, his enemies, shall be dispossessed. Israel is doing valiantly. And one from Jacob shall exercise dominion and destroy the survivors of cities." This passage struck me with new amazement for the way God does things that are outside the confines I have placed upon Him. A king was fearful of the Israelites and called upon a diviner to curse Israel. God gave momentary sight to this man, an enemy of God, and he foretold the coming of Jesus. (He was later killed in battle

memories
of a place
of beauty
and goodness
are written
within
all of us.

creative basics

We have been made in the image of God; into His likeness.

With the Fall, there was a terrible distortion and disintegration of ourselves as image-bearers of God, but our true nature as image-bearers remains.

Jesus, who rescued us, is even now in the process of restoring His image in us.

Part of His restoration includes our aesthetic, creative sense.

God reveals Himself as we tend to the creative process in ourselves.

We bring pleasure to God when we worship through the creative process.

The world needs truth, beauty and goodness.

He delights when we create to bring about more of these within the grand narrative.

Solitude, silence and listening promote worshipful creativity.

Creativity is a stroll, a long walk with Jesus.

When we gaze upon the beauty of God, our art tends to tell a story.

Our creative process is a natural outpouring of having been with the Creator.

He has ordained us to be creative and champions our work.

against the Israelites.) God chooses any means to make His splendor known. God does not set prerequisites for the peoples of the earth to serve His purposes; He doesn't require the same distinctions that we do to place value or worth on something. Part of our discovery will include gentle whispers from a kind God who reveals our mis-perceptions of His character, His desires, and His purposes. He will expand and enlarge our hearts and minds to the end that we will see Him working in places we thought were dead or had little hope of resurrection. Look again at the following list of "Creative Basics" from Chapter 1:

Where do these basics expand your ideas about how God views our creativity? **Do you believe that He indeed champions your expressions of creativity?** We all have places in our stories that have assaulted this truth. We will uncover where we believe lies and exchange them for truth. In order to FLY FORWARD with more creative freedom, we must hear life-giving words of Jesus and allow them to sink deeply into our inner sanctuary. Thomas Kelly calls this "centering down."

Let's peruse the subject of glory and shame and how that plays out in our journey of creativity. We all have a yearning for doing something well. We were made for glory. It's written upon us. It doesn't feel right when our work isn't compelling or transformative or haunting or moving to another person. We have a memory of what we were made for. Although the Fall distorted that memory of the Garden, we retain knowledge of God's desires for how things ought to be. We bear the image of God, which means the truth of our essence is still present. God made us to long for glory. It is not shameful to desire that. What happens when we fall short of the glory of God? Many times, our failures in reflecting His glory breed shame in our hearts. However, we do have Jesus who is a companion as we experience shame; He is the One who has tasted glory and shame, life and death.

Hebrews 2:8-9, "At present, we do not yet see everything in subjection to Him. But we do see Him who for a little while was made lower than the angels, namely Jesus, crowned with glory and honor because of the suffering of death, so that by the grace of God He might taste death for everyone." Offering and suffering came before glory and honor. In fact, Hebrews says Jesus was crowned

where do these **basics expand your ideas** about how God *views our* creativity?

with glory and honor because of suffering and death. He did not sample death; He drank deeply and swallowed it. Not until Jesus experienced shame, suffering, and death did He return to glory. There is no glory without pain. We've all experienced this. It's a theme in the great narrative. Because of the Fall, we must taste death. Jesus said that we must lose our lives to gain them. We are on our way back to what we were intended to be, and we will exceed that when we eventually are glorified. In the meantime, we experience the road that leads us back home. We have died creative deaths. The resurrection is coming.

At present, we do not see everything in subjection to Jesus. We see our incomplete works and failures as things to be quantified. Dr. Dan Doriani gave a presentation at the ArtHouse in Nashville in which he said, "As we learn to recover the glory we were made for, we must be liberated from false thinking. We say, 'I failed, but it wasn't me. I didn't do the best I could.' Jesus liberates us to say, 'I did the best I could and it was bad.'"[1] Because Jesus has tasted our shame, we are liberated to enter into the process of creativity and fail. In truth, we're fallen and we will bring our fallenness into our creative attempts. Do you give yourself permission to do something badly? You cannot learn your artistry without allowing yourself to have a beginner's mind for a season. "I did the best I could and it was bad." We will learn that we, if we're to follow Jesus, we must understand suffering for a little while. Out of sufferings come offerings that delight Jesus. Failing does not need to be shameful. Yes, there is an ache in the failing, and it needs to be grieved because we're made to be glorious. But our end goal is not a masterpiece. I have learned that the creative process is truly that: a process. Every perceived failure is a creative process. What was learned from doing it wrong will be applied to the next attempt. The next articulation of a piece of art will express learning from the previous expression. You will not like everything you make. Understand that it doesn't mean that you are not an artist just because you've judged something you've made with dislike. I remember my art professor, John Donovan, saying in a foundation class, that creating art can be frustrating because for every 25 projects, you might like one.

do you give **yourself permission** to do *something* **badly?**

Let's look at the antithesis of that statement: "I did the best I could and it was good!" Both of these phrases give us hang-ups. The bottom line is that it is difficult for us to be authentic with ourselves about what we do. The perfectionist will NEVER proclaim something done very well as "good," because in the perfectionist's mind, it can always be improved upon. Have you ever tweaked and tweaked and tweaked a project, fidgeting over the smallest details? It's as if we're avoiding the end. If I sign the painting, I'm putting my approval on it that it is complete. If I write the last chapter, I have to present it to the world. If the perfectionist can't conclude, she doesn't have to present her work to the world. But what if we looked at our work and genuinely liked it? Could you say that out loud? Could you celebrate with God and take delight in something you made? I truly hope we can do more of that. God does it, whether we can hear it or not, whether we join in or not. Perhaps as we have our hands in the creative process more often, we will begin to hear it. We can't hear the sun when its roaring gases explode in symphony and fire, but it doesn't change the fact that those glorious sounds are present and God can hear them. Our creativeprocess is similar. God takes great pleasure, whether we take notice or not. Let's join in. Celebrate your movements with Jesus through creative processes.

We must accept the position of a beginner. Then, when something is produced that is truly a breathtaking work, because we've had the freedom to do it badly and further explore, we then have the freedom to celebrate over work done well. This is the challenge for being engaged in a creative process. The next time you notice severe judgement coming from within yourself, extend some kindness to yourself; what is needed is further exploration.

These artistic pitfalls, failure and perfectionism, are on the opposite ends of the spectrum. They both have the power to freeze us or cause us to walk away from what we love. Perfection is not measurable. One particular piece will be rendered in a myriad of ways; as endless a count as there are people in the world. Failure is an illusion; not because it doesn't exist, but because of the way our culture approaches it. Our families, our schools, our churches and the culture at large reward success (something done well). When we fail, we are told that we're

not cut out that way and to stop trying. So, we feel shame and put that thing down, never to pick it up again. And, it's a source of pain that when brought up, can send us away wincing. We are taught that to fail means that we are faulty. Be encouraged by this quote from Thomas Edison who said: "Results? Why, man, I have gotten lots of results! If I find 10,000 ways something won't work, I haven't failed. I am not discouraged, because every wrong attempt is often a step forward." We need to be careful not to interpret our "wrong attempts" as a mistake of calling. Your calling is where your passion lies. Frederick Buechner explained, "The place God calls you to is the place where your deep gladness and the world's deep hunger meet." God has given us desires for our callings. It is not helpful to measure advancements toward your calling by success and failure. We are not after results. We are after the journey. It is the process that God brings beauty to; the end product will only be as beautiful as the process has been.

Perfectionism is our fear of not being good enough. If we can't be good enough, we don't even want to attempt to do something challenging. Ultimately, on our own, it's true that we are not good enough… but God is. We are hidden with Christ in God. Because we abide in Christ and He abides in us, we can meet our challenges. We have freedom to create apart from our perfectionism. As we learn to listen to Jesus, we hear His love for our process rather than our hatred of our product. When we hear Jesus, we realize there is no room for self-loathing or despising of anything we produce. We start to enjoy and engage in the process. It becomes less about a perfect finished product and more about a long stroll with Jesus as we brood over a blank canvas or peruse an empty page. Jesus sees your blank canvas and says, "Come with Me; let's go to another place together as I show you something about Myself that you've never seen before. As you paint, you can peer into My heart and reveal what you see to the rest of the world." In so doing, Jesus releases us from displaying "our artwork." He releases us from hoarding our vision, idea, book, painting, originality. We freely give it away because whatever we think belongs to us only captures us for a moment. Then God releases it from our grip to touch others as it touched us. Measuring the perfection of the gift is implausible. Perfectionism can only stunt the gift. We

are on a path back to glory. Reaching the destination without treading the path is impossible. Our glory would be formless and void. We need to understand while treading the path that Jesus has gone before us. He turns to us and says, "I am great and glorious and I accept you as great along with me." (We have been hidden with Christ in God.) Dan Doriani said, "The greatness that you have been seeking can now properly enter into your life. He brings us along into His greatness. He calls us great because we belong to Him. He is not ashamed to call us brothers (Hebrews 2)."[1]

I love Psalm 18! It was written by David after the defeat of his enemy Saul, who was seeking David's life. Much of this Psalm is a description of how God equipped David for the battle. God made David great! David describes this in detail. It led him to worship God. David had no shame in declaring himself great. He says, "Your gentleness made me great." For David, this statement was an act of worship. He wasn't puffing himself up. In this Psalm, he never claims responsibility for his greatness but he acknowledges the works God was doing in and through him. Simply belonging to Jesus and having His life credited as ours makes us great along with Him. What is keeping you from acknowledging that you have greatness in you?

Our shame and failure come along with us as well as our greatness. How do we work this out? We have to persevere through doing things badly. How do we encourage continued exploration regardless of our perceived failure? Dr. Doriani says that anything worth doing well is worth doing badly. It is better to fail than not try at all. Rembrandt was rejected as an artist. Van Gogh was not a known artist until after he died. How many times was J.K. Rowling rejected before finally publishing the Harry Potter series? Geniuses like these keep going without initial mass audience success. Dr. Doriani says, **"We must be assured that if God alone values our work and creative process, we have the freedom to continue in it!"**[1]

Our creative process must have its origin in the presence of God. The Audience of One is the most significant audience there is. When we begin to believe that God has ordained any creativity that flows out of us, we come to a

we must be *assured* that if God alone *values our work* and creative process **we have the freedom** *to continue in it!*

deeper understanding of that process. Not only does He sanction the creative process, He is causing it to happen. The creative process begins to look more like a conversation between you and the Creator rather than a disconnected crafty activity to fill time or practical purposes. Our art becomes a natural expression of our private conversations with the Lord. Once we begin to edit and revise based on what the larger audience wants to see or hear, we lose some of the authenticity that the private conversation brought to it. If we do art for the applause of those outside that "Audience of One," something is lost. Community can speak into the art that we do, but it must originate with only One.

When we begin with the audience of One, we find safety and freedom to explore. We explore different techniques, art forms, ideas with freedom. We have found a place free of judgment, expectation, or critique. Hopefully, you know and have identified the people in your life who offer that kind of space as well. I would caution you to be careful about letting those who are not champions of your creative path see your work. You have creative wounds and for now, you need to shield yourself from further injury. Boldness about displaying your work can come later. As you begin creative exploration again, be aware of those around you that could cause you to return to seclusion and despair. Assaults on the truth will continue to scream in your ears. As you reorient your thinking about creativity, protect your creative self from harmfulenvironments. You know who the people are that have power over you in this way. You may not need to cut them off completely, but certainly don't engage them in this early part of your awakening captivity. It is appropriate to grieve over the fact that you can't bring everyone with you where you are traveling, but it is prudent to guard yourself in this way.

We also feel shame over our infirmities, the mundane in our lives, the absence of glory… things that are not sin, but are results of a fallen world but are results of a fallen world. What do we do with weaknesses and limitations? We start by identifying infirmities and embracing them as part of ourselves. Jesus embraced everything that makes me who I am. Am I so presumptuous that I would reject what He has accepted? The embrace of our poverty by Jesus

and ourselves will change us. It will squeeze shame out the sides. Embrace your infirmities, that the power of Jesus will be made mysteriously and wonderfully manifest through them.

The Joy of Creativity

Are you finding joy in being creative? Or do you view creativity more in terms of an assembly line where the product is the ultimate concern? Productivity and duty are two words that are not paired well with artistry. Stay in the joy of doing what it is you are called to do. Productivity is what the world values, but it is not a reliable measure of success. Art is not productive, nor is restoring glory to God, in the world's view. But it is the work the world is hungry for! We need beauty in this world! Unless we're after something other than a product we will not find joy in creating. To find joy, we must stroll slowly along the path with Jesus and savor the becoming. Quality comes with communion. If our art reflects this stroll, the depth of communion with Him will show up in the quality of our work. When we lose sight of the process, which is more valuable than the product at the end of the process, we have lost the joy of creating.

Creativity is our true nature. We were made for glory. But in order to restore what was lost, some detective work must be done. Where we are fearful of expressing ourselves is where our wounds speak louder than our courage. We need Jesus to take us back to the places of woundedness and weakness to be properly healed. Jesus is the wrecking ball and the re-builder. He will make glorious castles out of the ruins, but He must also knock our fabricated buildings down. Throughout this book we will seek to unlock the ways in which our creativity has been stifled. We are all image bearers, which means we all have the capacity to create and respond to beauty. Because of the fallen world around us and within us, we must learn to rely on the Holy Spirit to tap into that creativity heal and what hinders it. This is a restorative process that we will live out for the rest of our lives. It is a journey God takes us on to restore us to Himself. Our relationship with Him is really the essence of our creativity.

Identity

When it comes to recovering a sense of identity, it's necessary to return to our roots. This includes our family of origin, but more importantly, it means examining the Creator/creature relationship. How did we start out? Who am I, as one who has purposefully been designed and formed? What are His desires for me? What does He dream about for me? What does this look like in terms of Creation/Fall/Redemption/Consummation? As a result of the Fall, the image of God in man has been severely distorted. But as God is committed to making all things new and the redemption of His creation, we look for Him to restore the loss of beauty. "Our sense of beauty is a feeble reflection of the God who scatters beauty profusely over snow-crowned peaks, lake-jeweled valleys, and awe-inspiring sunsets. Our gift of speech is an imitation of him who constantly speaks to us, both in his world and in his word. And our gift of song echoes the God who rejoices over us with singing (Zeph. 3:17)." (Hoekema)[2] We, each in our own way, have the ability to imitate God and bring restoration of order to His world. He allows us to participate in this wondrous process. In so doing, we reflect His character back to the world. This is my calling and yours.

Our capacity for reflecting God's image has its limitations, though we are promised that we are being renewed and regenerated. How does He hook you back into the loop of more love and life? In faith, we move forward into our callings with confidence, trusting that God will indeed reflect Himself through us! Ask yourself this very important question: Where do your passion and the world's deep hunger intersect? This will reveal much about how you and Jesus decide to express your identity out in the world your identity out in the world. If you don't know, ask Jesus. Ask Him in solitude.

EMERGING CREATIVITY

Saying goodbye instead of saying hello
Your essence vanished but I did not go…
I traveled far but went nowhere
Ran away, into the dark power that is fully aware.
Hazy vision, blurring shape
Cold, fearless light summons me to awake…
Distant sounds resonate in my head
I hold tight in the sway of this unfamiliar bed.
I hear the voices call my name muffled, unclear
There is a screaming in my head, my lips silenced with fear…
Am I in a world I recognize or somewhere unknown?
I seem to stay only a moment then I drift away to roam.
It is over before I understand
Soft strokes of comfort pat my hand…
I hear one tell me I will be okay
Yet I destroyed a piece of myself in this foolish way.
A grief immense beyond what one would tell
Propelled into a loss creating an empty well…
The severance steals dignity, an assaulting fake
That can only produce barren regret and wounding heartache.
Day upon day, lonely and numb
Lost forever is the familiarity of tiny toes, sucking thumbs…
What of hair color or face or a life lived great?
The tears begin and cannot stop under such suffocating weight.

Who was he, who was she?
Ripped away from my body, no source of autonomy or free…
I did not have courage to watch him grow, nor embrace her face
A humbled celebrant mismatched to this forsaking place.
God came and rescued me for a new start
His healing revealed your claim to my heart…
I live within faith that He knew how we would end
Choosing to forgive all, He our saving friend.
I will see you my beloved in the beauty of the other side
There precious babies rejoice as the glorious Bride…
My heart is the vessel where your memory remains
Someday I will hear Him call your holy, special name.
For a micro-moment, you had a mother
Me, I had a child gone, then grace of another…
Sadly, I surrendered to pay abortion's high cost
You, however, fulfilled your life in a love that can never be lost.
I love you, sweetie pie. Jesus to me… me to you… forever.

QUESTIONS FOR REFLECTION

Day 1: What are some ways that being made in the image of God could manifest itself?

Day 2: What is something you won't allow yourself to do because you might do it badly? Why are you afraid to do it badly?

Day 3: How has shame played a part in your creative inhibitions?

Day 4: Identify some of your weaknesses/infirmities. How has God used these things to manifest His power?

Day 5: Do you believe that God values your creative work and creative process? Is that enough for you? Why or why not?

Day 6: Think of a time that you have failed creatively. How has this failure kept you from further exploration?

Day 7: What is something that you feel God wants to resurrect in you? What can you do to submit to that work He wants to do in you?

SOLITARY PERUSINGS

Take one of the "Creative Basics" that stands out to you; it doesn't matter why it stands out. Write it down in your journal after some time spent quietly with Jesus. Then write the flood of messages you hear in your mind. Everything. You will start to unearth any subtle lies you give credence to. Let the floodgates open. Then go back to the phrase. Write it down again. Again, record the flood. Come back to the phrase again. Invite Jesus into the conversation you are having with yourself. What do you notice about the messages you are hearing? Are they kind? Are they cruel? Are they critical? Are they barriers to worship? Are they true? Do you feel their power? Jesus will never speak words to you that lead you away from love or life. What is He saying about His truth to you? Listen to Him. Write it down. There will still be arguments in your mind as you bring Him into this conversation. Let Him speak into the arguments. Record all that is being said in your mind. Once the arguments subside and you are left gazing at Jesus, rest with Him. Be with Him and believe what He says about you!

WAKING UP *grey*

Today the table was calling particularly loudly for Grey. She feared to come and sit. She could not presume that such a beautiful table was intended for her. But the invitation called her by name. She cautiously approached. Oh how lovely and breathtaking it was; the finest linens and settings, adorned with stunning, fragrant flowers. The aroma of the feast, which was the finest of everything, beckoned her. She was prepared to ask for crumbs, but the Host said, "This meal is for you. Partake and be filled!" She sat and feasted, drinking in its loveliness. She lost herself in the smells, the sights, the sounds, and most of all, the conversation between herself and her Lover. The conversation changed her that day. She knew she was created to feast at that table. In all vigilance, she wanted to protect the times she would meet with her Master and enjoy the "richest of fare." It became important to stop doing things for the Master without having feasted. Because of the Master's unrelenting and fierce love, she began to wake up to passion...

three

ART IS PROFOUNDLY SPIRITUAL

Contemplative and Listening Prayer

I grew up watching Anne of Green Gables. It was one of my favorite stories. It was Anne Shirley, the heroine, who first taught me to think differently about prayers. Anne was an orphan and had just come to live with an older woman and her brother. The woman, Marilla, was a pious, religious woman and insisted that this new orphan say her prayers. On a discussion about what a "proper" prayer was, Anne responded, "If I really wanted to pray, I'd go outside into the middle of a field and pretend it was the dome of a great cathedral and then I'd just 'feel' the prayer." Her beautiful idea of prayer was so unlike the conventional ways I'd been taught to pray. To pray outside, brushed up against nature, perceiving God through imagination with no words was entirely a new idea to me. This notion stayed with me for a while and had time to germinate; I didn't visit the idea of praying with my imagination until much later. Prayer is as unique and nuanced as humans are. Perhaps that is why books on prayer are so

my community:

numerous. One thing I do know about prayer is that is is based on relationship. It is a conversation, and can carry our conversation into the creative process.

In contrast to the eastern religion model of "emptying our minds," contemplative and listening prayer is the practice of bringing our thoughts captive to Christ. As we gaze upon God's beauty, we learn to bring our intellect under obedience to Him. Conversing with God through prayer is a way of loving Him with all our minds. As Christ captivates our thoughts, we find that He is huge and our minds cannot encompass Him. Jesus captivates our thoughts and we find He begins to broaden the confinements we have imposed upon Him. "Keeping an open mind" is far too small an admonition! It is a paradox: As Christ captures our minds, we find that His ways are too large to be contained and that our "open minds" really become submitted minds to a vastness that remains mysterious. As we submit to Christ in our minds, we find unexpected, surprising and unsearchable ways in which God shows up and reveals Himself. This is what it means to love the Lord our God with all our minds.

In solitary prayer, we also have the opportunity to love Him with all our heart, soul, and strength. Dietrich Bonhoeffer said, "Contemplationis the adoring gaze of the soul upon God's beauty."[1] I would also add that it is allowing Him to return the gaze. This adoring gaze encompasses the whole person; the heart, soul, mind, body, imagination and strength of the gazer. When you're in the presence of Jesus, gazing upon His beauty, always have pen and paper close to hand. You'll want to write what you see and hear. Write what comes and resist the temptation to edit! My writing during solitary times has become a dialogue with God. Journaling has become letters in which He speaks loving, affirming words to me. Writing has become an exploration of the heart and mind of God. His heart is a place of sanity; a place for quiet listening, contemplative writing, and asking questions that don't have or need solutions Writing helps us ponder subjects that need perusing in the presence of God It's a sacred space in time where the Shepherd draws us into green pastures for warmth, nourishment, and play. Perhaps the idea of writing words in a journal is a loathsome thought to you. Why not use images instead? Keep a visual inventory in your journal that

may or may not include words. Take notice of what is going on inside. Listen to the protests. Observe the spark igniting. Even listen to the fear. Give whatever is rising, some space to surface.

The Gift of Community

I can't discuss solitude without addressing the practice of community! We need each other. Those of us who are very comfortable with silence can tend to isolate ourselves. And those at home with a crowd can avoid being alone. Neither is God's intention for us as artists or as followers of Jesus. Proverbs is full of strong exhortations about the wisdom of "many advisors." Silence and solitude are vital elements in creative awakening, but in tandem with the broader context of community. We bring community into our solitude. We bring our solitude into community. They impact one another. Dietrich Bonhoeffer wrote, "Let him who cannot be alone beware of community. Let him who is not in community beware of being alone. Each by itself has profound pitfalls and perils. One who wants fellowship without solitude plunges into the void of words and feelings, and one who seeks solitude without fellowship perishes in the abyss of vanity, self-infatuation, and despair. The mark of solitude is silence, as speech is the mark of community. Silence and speech have the same inner correspondence and difference as do solitude and community. One does not exist without the other. Right speech comes out of silence, and right silence comes out of speech."[2]

I see God's design for community at work on those days that I just can't quite get started. Even though I have a clear idea of the things I want to accomplish creatively and otherwise, I can't seem to get going. It isn't laziness or procrastination at its root. It's something else. Feelings of being overwhelmed seep into my heart and paralysis sets in. I spend the day checked into the motel of numbness, injecting my narcotic of choice, be it food, shopping, sleeping; name your pleasure. We all have these days. But have you ever had a day when you saw it happening but something or someone arrested your attention and gave you what you needed to reengage your life and work? I have. That is the compassion of Jesus embracing us through community. Today was a day like that.

I was consumed with how much work there was to do, how much wasn't getting done, and not knowing where to begin. But Jesus sent my friend Tori to speak truth and help refocus my gaze. The compassion of God sometimes comes to us through a friend when we can't be compassionate toward ourselves. When we've allowed the volume of harmful voices to drown out the truth, it is then that He will send someone to be His voice for us. This is why walking in community is so important. Do you have someone you can call when you feel yourself retreating into the motel of numbness and medication? Who can intercede for you? Who can you be weak with and from whom you can borrow faith? "As iron sharpens iron, so one man sharpens another" (Proverbs 27:17).

Principles for Listening Prayer

When I discuss listening prayer, it is sometimes met with skepticism. Listening prayer is the act of engaging your intellect, heart, imagination and will to experience Jesus and let Him speak to you. You will never hear Him say something that doesn't align with scripture. Let us focus first on the "dilectio" part of prayer in which "the Holy Spirit preaches to you." If you are a believer, you have within you the Holy Spirit to teach, remind, guide, instruct and reveal.

God speaks to us through the Holy Spirit who has chosen to make our hearts His dwelling place. We learn to turn down the volume of voices other than this Spirit within us. We turn down disapproving messages from our family of origin. We turn down enemies whispering in our ear. We turn down the lies we tell ourselves and the lies we hear from others. 1 Corinthians 2:10-13 says, "These things God has revealed to us through the Spirit. For the Spirit searches everything, even the depths of God. For who knows a person's thoughts except the spirit of that person, which is in him? So also no one comprehends the thoughts of God except the Spirit of God. Now we have received not the spirit of the world, but the Spirit who is from God, that we might understand the things freely given us by God. And we impart this in words not taught by human wisdom but taught by the Spirit, interpreting spiritual truths to those who are spiritual." Do we really understand the unsearchable riches that have

been revealed to us in this passage? The Spirit searches the depths of God. To us, the depths of God are unsearchable. Yet, we have access to this vast depth because we have been given the Spirit who has been to the deep! We can try and understand this cognitively, but unless we come to the table of solitude to listen and allow the Spirit to teach us about the depths of God, we won't understand it through intimate experience.

the Holy Spirit speaks through:

- Scripture, spiritual reading, hymns and songs
- Worship and liturgy
- The "still, small voice" or "gentle whisper" in the soul
- The imagination: thoughts, impressions, images, visions, dreams
- Creation and nature
- Trials, afflictions, frustrations, commonplace events, etc.
- Books, art, stories, movies, music
- People

As you use your mind, heart, and will to gaze upon the glory of God, you may have a difficult time settling into solitude. Your mind will race with the happenings of the day, with tasks, relationships, etc. Ask Jesus to take your thoughts captive and bring them under His obedience. It may take patience and perseverance to focus your attention on Jesus. Take your time. As you sit and let Him "quiet you with His love," ask Him the questions below and write down what you hear. Let your focus be on your relationship as His beloved. His love toward us is kind. If you hear anything that is unkind, it is not from Him. Even His exposing is kind (Ephesians 2:7; Hosea 11:4; Romans 2:4). You might not write the words you expect or you may not use words at all. God may use an image or a poem to speak to you. Sketch the image. Write the poem.

Part of our resistance to contemplative prayer is that stillness will collide with our poverty. If we have not endured this collision, we have not yet truly experienced solitude in a contemplative sense. A collision of this force will turn

who "*got*" you?

our spirituality upside down and we will never return to what we were before impact. We come unembellished and bare when we approach The Altar. We have nothing of value to offer and win God's favor yet we are still invited to be there. We are more than invited. Our presence is desired. Richard Rohr says, "Being nothing has a glorious tradition. When we are nothing, we are in a fine position to receive everything from God... The desert is where we are voluntarily under-stimulated. No feedback. No new data. That's why He says to go into the closet. That's where we stop living out of other people's responses to us."[3]

To Be Gotten

Listening… we use this word flippantly every day. We tell our children to listen to us. We ask our spouses, parents, and friends to listen. We want to be heard. There is no greater feeling than to be heard; to be understood. To quote Bruce Willis in the movie, The Story of Us, "There is no greater feeling in the world than to be gotten." How wonderful and intoxicating it feels "to be gotten"; to know that another person has seen, heard and understood you; has accepted you fully and has taken delight and pleasure in you. "To be gotten" is a taste of heaven. Can you think of a time that you felt this way? Who "got" you? Do you remember what led up to it? We spend so much of our time trying to make ourselves heard that we become part of the listening problem. Have you ever noticed how few really good listeners there are? Our world is full of non-listeners. Maybe that is why our world is so loud. We are a great cloud of witnesses clamoring for our turn to get to the mike. We are so focused on being heard that we haven't listened.

My friend, Nita, says that listening requires curiosity. To listen means to be more than just polite, quiet people who don't interrupt. Listening is active. It is the art of experiencing life through another's eyes. It requires that we walk into the soul of another. We cannot offer this gift unless we are curious. When you formulate a response in your mind while someone is speaking, you have just lost your ability to experience another's view. Active listening does not consist of sharing a similar experience in order to have a connection. Active listening is

engaging in the experience of another without reference to you. What you bring are limitations of your own experience. Active listening involves placing yourself in the scene of another, observing all that is there, trying to imagine the sights, sounds, images, colors, smells, and textures. As you become a listener, a true listener, your curiosity will draw you to probe for more information. You may ask questions that have not been asked before. The moment you shift your focus from your experience to theirs, you have become a fellow sojourner.

Listening is what it takes to regain a sense of connection. Learning how to listen to the Holy Spirit will reconnect us with our Lord. As we become acquainted with His voice, we will also start to listen to those around us. We become listening learners and learning listeners. As we sit with the Lord and learn to be "gotten," we start to "get" Him more deeply. We begin to understand God's heart for us, for others and for His world. We all have a deep need to know and be known. No one truly understands you more than He does. Experiencing His presence in the posture of listening will give you the deepest longing of your heart—the assurance of knowing you are His beloved. If you experience being "gotten" by the One who has redeemed your very soul, you are free to offer yourself as one who listens well. It doesn't remove the pain of not being heard by those who matter to you, but in that pain you won't spend everything you have on making yourself heard.

One of the barriers to listening is the fear of what we might hear. Our resistance to being quiet before the Lord is due in large part to our fear that God may ask something of us. Listening may require suffering and relinquishing control. Upon the declaration that he would listen, Samuel received a disturbing command to deliver this message: "And the Lord came and stood, calling as at other times, 'Samuel! Samuel!' And Samuel said, 'Speak, for your servant hears.' Then the Lord said to Samuel, 'Behold, I am about to do a thing in Israel at which the two ears of everyone who hears it will tingle. On that day I will fulfill against Eli all that I have spoken concerning his house, from beginning to end. And I declare to him that I am about to punish his house forever, for the iniquity that he knew, because his sons were blaspheming God, and he did not restrain

what would the
Master say to you?

them. Therefore I swear to the house of Eli that the iniquity of Eli's house shall not be atoned for by sacrifice of offering forever" (I Samuel 3:10-14).

Ouch! When Samuel made the choice to listen, he unwittingly chose to suffer. God entrusted to him a message that was terribly painful to deliver. It says in verse 15 that Samuel was afraid to deliver the message. Our culture and our lives have become so loud that I wonder if we do this to avoid listening. When we restrict our listening, we miss discovering God's heart for His world, His longing, sorrow and joy. Joy comes in hearing God delight in those He has redeemed. Listening helps us to return to sanity. His words to us are so kind. He gossips His loving kindness in our ears! Do you remember the movie *Dead Poets Society*, in which Robin Williams plays an English teacher who passes on his love for life and passion for beauty to his students? There is a scene in which the boys are awakened to the insatiable hunger for beauty and imagination. The teacher directs them to lean in and listen to photographs of students from years past. They are all leaning in, staring with wonder and imaginative pursuit as he whispers into the contemplative silence, "Carpe… diem, Carpe… diem, Carpe… diem. Seize the day, boys. Seize the day." What would you hear in contemplative silence? What would the Master say to you? He rejoices over you with loud singing. Have you heard it? What would it be like to lean in expectantly; not to old photographs, but into the Word, and hear what He would say to you? What does His singing sound like to you today? Lean in with wonder and listen...

Not Being Heard

I have learned the art of being autonomous and self-sufficient in my speech. I have developed an intricate method of gauging whether others will listen to me. Do you have that same internal gauge? It comes from my own insecurity and living long enough in a world of poor listeners. People will ask me questions and I give them the short answer, "knowing" they are just being polite and not truly interested. When I am proven right, it gives me further justification for closing off and protecting myself from rejection. I prefer self-protection over taking the risk of letting others care about me. This gives me far too much power.

I learn to rely on perceptions that may be inaccurate and cut off any chance of a healthy, intimate relationship. I'm not saying that protecting oneself is always inappropriate. You can probably identify people in your life with power to injure, and it would be reckless to let them reopen those wounds. But you can tell when you are operating out of prudent caution and when it is closer to irritable cynicism. I long for the day when our internal gauges that keep us from deep connection can be properly healed as we take our great disappointment over not being heard to the One who heals.

The Wilderness of Rest

Your journal exercises will become a place of rest and reassurance from our Savior. They will provide refuge, rebuke, restoration and refreshment. Look to your writing as an opportunity to have an intimate conversation with the Shepherd. Pay attention to those days when "getting to it" seems especially difficult. Walk through the anxiety and "get to it" anyway. It will be those days that profound thoughts and feelings will show up on the page. Many times, if the fight of the day is a bit bloodier than most, it is then that the epiphany comes to you. Press through.

Since starting this course, have you spent more time in solitude? If so, what's it been like? Has it gotten easier? Has it been a feast for your soul? Are you settling in or are you resistant to it? If so, what are your hesitations? Is it perhaps a luxury that you can't afford? Is it simply a "nice aside" when there is time in the schedule? Is it an impossibility with the loudness of life? Does it feel like drudgery? If you answered "yes" to any of these attitudes, I want to challenge you. Our time alone for reconnection with Jesus is a lifeline. It is a necessity, not a luxury. It was a necessity for Jesus when He lived among us. He got away from the crowds, the beggars, the lepers all clamoring to be healed. He even got away from His friends and family. Jesus stole away to pray. Sometimes He would take disciples. Sometimes He went alone. After Jesus was baptized, the "Spirit immediately drove Him into the wilderness" (Mark 1:12). He was alone for forty days, contending with wild beasts and an empty stomach. On top of all that,

SOLITUDE
what are your *hesitations*?
has it gotten easier?

art,
many
times,
is born
out of
pain
and tension ...
but it doesn't have to be.

Satan made visits to Him. We know the Holy Spirit led Him into the wilderness. Has the Holy Spirit ever led you into solitude? Have you followed? We know the Holy Spirit was with Jesus, as "the angels were ministering to Him." The Holy Spirit led Him into the wilderness to be alone with God. They must have had some great conversations. What fellowship they must have enjoyed. Jesus faced distractions just as we do, and He needed help from the Holy Spirit in contending with them. As do we.

Jesus invites us to the banqueting table, but we don't always accept the invitation. Why is this? One reason could be that it requires a change in our inner posture. We have to wait and observe. Jesus probably did a lot of waiting and observing in the wilderness. Richard Rohr writes, "That's what happens in the early stages of contemplation (the waiting and observing). We wait in silence. In silence all our usual patterns assault us. Our patterns of control, addiction, negativity, tension, anger, and fear assert themselves. That's why most people give up rather quickly. When the Spirit leads Jesus into the wilderness, the first things that show up are wild beasts. Contemplation is not first of all consoling. It's only real."[3] Contemplation starts out as a fight. It is not consoling; it is quite the contrary. The patterns Rohr lists are the wild beasts. As you enter solitude, the wild beasts become ravenous. If you stop to feed your soul, the wild beasts starve and so their howling becomes louder and louder. If you can make it to the point where the howling subsides (which is done in the waiting and observing), the contemplative work can continue. Rohr says, "True prayer is the antidote for creative blockages. With great difficulty, even death, true prayer moves us beyond the reward/punishment mentality."[3] Sometimes the waiting and observing will take a while. There are many wild beasts that must relinquish themselves to the silence. But to stay there, in that place, is the way through. Rohr writes, "God alone seems capable of guiding us through transitional dark stages."[3] It is in the dark stages that we experience the balm for our fears and anxieties that come with us into the solitude. Do not leave your anxiety and poverty outside the throne room! Bring them with you. Jesus is not a stranger to your poverty. He actually became that poverty the day He died. He is very familiar with it and it

does not bring Him fear or anxiety. "Once our defenses are out of the way and we are humble and poor, truth is allowed to show itself,"[3] says Rohr. When we get to this place, it is then that we experience deep and abiding rest. We see God; we experience Him in His splendor. The solitude turns to worship, or as John Calvin called it, "awareness of divinity." Sometimes we can get caught up in our cerebral culture. We miss the simplicity of our faith and our creating as just being.

Sometimes, all we need is to bring our minds into awareness that the Lord is present in this very moment. Our theoretical knowledge shifts into experiential presence. We allow this knowledge to soak into our hearts, minds, souls and bodies. This is not an attempt to achieve something. Rohr writes, "We cannot attain the presence of God because we're already totally in the presence of God. What's absent is awareness. Little do we realize that God is maintaining us in existence with every breath we take. As we take another it means that God is choosing us now and now and now. We have nothing to attain or even learn."[4]

Astonishing

Art is a process of prayer. Art, many times, is born out of pain and tension. Art takes twists and turns and the end result may be nothing close to the vision we started with. Sometimes we find ourselves surprised by the unexpected conclusions the artistic process has led us to. By engaging in the process of creating art, somehow we grow and change. In turn, our art grows and changes. Allow yourself room for these alterations and invite God into the conversation. This is where intimate listening prayer comes in.

"To be an artist is to acknowledge the astonishing," writes Julia Cameron in her book, *Artist's Way.*[5] This is what links artistry to the spiritual journey. Creating is a spiritual act of worship. Even creators who don't believe in God are reflecting His creativity. We have been created by God to be worshipers; creating is our oil of worship. What do we worship when we create? What is astonishing to you? As the ones Jesus calls to be awake and watchful, we are astonished because we see the Creator's mark in everything! We anoint "little altars everywhere" with our oil of worship and invite others to join in the astonishment and worship of

what is
ASTONISHING
to you?

the one true God, our Lord Jesus. It starts to look like this: "Love people even in their sin, for that is the semblance of Divine Love and is the highest love on earth. Love all of God's creation, the whole and every grain of sand of it. Love every leaf, every ray of God's light. Love the animals, love the plants, love everything. If you love everything, you will perceive the divine mystery in things. Once you perceive it, you will begin to comprehend it better every day. And you will come at last to love the whole world with an all-embracing love."[5]

"Contemplation results when the Holy Spirit comes and makes something objectively real into something that is also subjectively real to us." (Kevin Twit)

QUESTIONS FOR REFLECTION

Day 1: What is the connection between silence, solitude, and the act of creating?

Day 2: What is the connection between community and the act of creating?

Day 3: Name three reservations you have about spending time in solitude. Where do you think these come from? Ask Jesus about them.

Day 4: Name three reservations you have about being in community. Where do you think these come from? Ask Jesus about them.

Day 5: What astonishes you? Name some specific things. (It's different for everyone. A sunset may take my breath away, while your astonishment is found in a newborn baby.) Name five things that have the power to astonish you.

Day 6: Bring one thing that astonishes you into solitude. Ask Jesus what it is about that thing which has the power to astonish you. Listen and wait for His answer. Write down what you hear.

Day 7: What oil of worship have you given away that was intended for the Lord alone? Name it and ask Jesus to retrieve it for you. Spend some time writing words of worship in your journal.

SOLITARY PERUSINGS

Find a spot in your house: a place that brings you comfort. Carve out a sacred space in your home: a desk with a lamp, a corner with your favorite rocking chair, a spot in front of the window. Set it up with things that speak to you. It could be a photograph of a place you want to visit someday, a candle, a vase of fresh flowers, a favorite pillow, or a painting. It is your place; a retreat within your home. Spend some time there this week. Do your questions for reflections there, talk to Jesus, sketch, write poetry. Do what you feel led to do... just enjoy it and play! Also, for this week: Construct a miniature table. Make it out of whatever material you can find: wood, metal, stone, paper, etc. Just make sure it's three-dimensional. Make it simple with no embellishments. This will be an

ongoing project for the rest of your time in the text, so be certain to make the time for this activity. It would be a great activity to do in your sacred space.

WAKING UP *grey*

Today, after much resistance, Grey made it to the table. She knew it would be good to be at the table, but things always seemed to keep her from being there. Today, it was fierce anger. Through her toil, she realized that she must bring her anger to the table; after all, it was really directed at the Master. As she approached, His eyes of compassion invited her tears, as she noticed sadness beneath her rage. She grieved over loss: lost relationships, lost endeavors, lost time, lost emotion, lost opportunities, loss of self. She told Him she was afraid. If she moved forward in the things He was asking her to do, there would inevitably be more loss and sorrow. He told her that and she knew it in her heart. She also realized He was handing her a pearl of great price to steward. That alone was sufficient for moving forward. His gift had more power than any hesitation she had in following Him. That day, her answer was pure and simply, "Yes."

four

MOVING INTO THE GREY

True Self Versus the Impostor

Let's look at how your creativity has been wounded in the past. It is important to identify your wounds so that proper healing can begin. Perhaps you were afflicted by the sword of indifference, which can be just as devastating as the overtly critical response to your creative endeavors. My strong caution here is to be careful to consider these things against the backdrop of who Jesus says you are. Henri Nouwen writes, "Our sense that the Father wants us home must be greater than our sense of lostness."[1] Keep in mind, as you view your poverty and woundedness, feeling lost is a very real part of you. But it is only a part of you. What is more defining for you is that the Father wants you home!

We have times in our stories when we've been told that our true self wasn't acceptable. The fact that we bear God's image has been assaulted in each one of

us. Whenever it happened, it was also the moment when our impostor emerged. Thomas Merton described it this way:

"Every one of us is shadowed by an illusory person: a false self. This is the man I want myself to be but who cannot exist, because God does not know anything about him. And to be unknown of God is altogether too much privacy. My false and private self is the one who wants to exist outside the reach of God's will and God's love—outside of reality and outside of life. And such a self cannot help but be an illusion. We are not very good at recognizing illusions, least of all the ones we cherish about ourselves—the ones we were born with and which feed the roots of sin. For most people in the world, there is no greater subjective reality than this false self of theirs, which cannot exist. A life devoted to the cult of this shadow is what is called a life of sin."[2]

To cherish our illusions of self-sufficiency is to be our own god. To seek existence apart from God serves our desires for power and control. It means we have no need to seek Jesus to get to the truth of who we truly are: "I can carve out a glittering image for myself, thank you very much." Brennan Manning has this to say about it: "Our false self stubbornly blinds each of us to the light and the truth of our own emptiness and hollowness. We cannot acknowledge the darkness within. On the contrary, the impostor proclaims his darkness as the most luminous light, varnishing truth and distorting reality. This brings to mind the Apostle John's words: 'If we claim to be without sin, we deceive ourselves and the truth is not in us' (1 John 1:8)."[3]

What do we do with this person that we have constructed who would say "no" to authenticity? We must bring the impostor before Jesus in the silence and stillness. Until this impostor has been brought into the place where God dwells and has found refuge in Him, self contempt will reign supreme. In *Abba's Child*, Brennan Manning states,

The impostor must be called out of hiding, accepted, and embraced. He is an integral part of my total self. Whatever is denied cannot be

healed. To acknowledge humbly that I often inhabit an unreal world, that I have trivialized my relationship with God, and that I am driven by vain ambition, is the first blow in dismantling my glittering image. The honestyand willingness to stare down the false self dynamites the steel trapdoor of self-deception.

As we come to grips with our own selfishness and stupidity, we make friends with the impostor and accept that we are impoverished and broken and realize that, if we were not, we would be God. The art of gentleness toward ourselves leads to being gentle with others—and is a natural prerequisite for our presence to God in prayer.

Hatred of the impostor is actually self-hatred. The impostor and I constitute one person. Contempt for the false self gives vent to hostility, which manifests itself as general irritability—an irritation at the same faults in othersthat we hate in ourselves. Self-hatred always results in some form of self-destructive behavior.

Accepting the reality of our sinfulness means accepting our authentic self. Judas could not face his shadow; Peter could. The latter befriended the impostor within; the former raged against him. [4]

Do you believe that Jesus loves the unrepentent sinner? "While we were yet sinners, Christ died for us." Is there a behavior, practice or attitude that you still cling to and regard? Do you put energy into it that you wish you wouldn't? Do you know that you are deeply loved right in the center of that struggle? There is a place in each of us that holds the deepest shame. Have you allowed that very place to be touched by love? With His kindness and deep compassion, Jesus wants to touch that place that you are hiding from Him. Can you let Him see it?

I attended a workshop recently and met a wonderful new friend in Father Matthew Finn, who helped me understand the difference bewteen guilt and shame. He said that guilt is when I've done something wrong, but I'm aware of being loved and forgiven. Shame is when I've done something wrong and I don't feel loved or forgiven. In our places of shame that still need healing, we must let

love saturate and do its generative work down deep. This is what it means to face our shadows. And mysteriously, miraculously, these are the very places we can gift out into the world. Our hurt turns to gift.

The Scales Come Off

What are your triggers of self-sabotage? What leads you to feel that writing is burdensome? It becomes more than issues of time management, priorities, and preoccupation with busy lives. These are excuses we hide behind. There is a deeper fear driving our choices. Journaling should actually be a time of dialogue, a time of bringing Jesus into our lives, our questions, our art. We will avoid journal writing when we want to hide parts of ourselves. If we are being called to repentance, we may avoid being alone with Jesus at all costs. Yet, volatile emotions are the very things we need to write on the page. When we press through and find the page, we will identify the triggers that precede meltdowns, self-sabotage and acting out. Some triggers include boredom, pain, isolation, loneliness, fear, resistance to emotion, depression, irritation, grief, exhaustion, denial, and anger. We go to our vices to seek temporary comfort, relief and pleasure. If you would choose the pages over the idol, you might find a deeper connection with Jesus than you've experienced before. The comfort, relief and pleasure you experience will be real and long-lasting.

The creative process is a natural response to our fellowship with Jesus. It can be a way for us to stay hooked into love. We cannot manufacture it. We can pray for it; and wait for it. We can long for it. C.S. Lewis describes a wonderful picture of this waiting process in *The Voyage of the Dawn Treader*. The young boy in the story (Eustace) "had turned into a dragon while he was asleep. Sleeping on a dragon's hoard with greedy, dragonish thoughts in his heart, he had become a dragon himself." Here is the story of his transformation back into a boy with the lion (Aslan) as the Christ figure.

"Well, anyway, I looked up and saw the very last thing I expected: a huge lion coming slowly towards me. And one queer thing was that there was

no moon last night, but there was moonlight where the lion was. So it came nearer and nearer. I was terribly afraid of it. You may think that, being a dragon, I could have knocked any lion out easily enough. But it wasn't that kind of fear. I wasn't afraid of it eating me, I was just afraid of it—if you can understand. Well, it came closer up to me and looked straight into my eyes. And I shut my eyes tight. But that wasn't any good because it told me to follow it."

"You mean it spoke?"

"I don't know. Now that you mention it, I don't think it did. But it told me all the same. And I knew I'd have to do what it told me, so I got up and followed it. And it led me a long way into the mountains. And there was always this moonlight over and round the lion wherever we went. So at last we came to the top of a mountain I'd never seen before and on the top of this mountain there was a garden—trees and fruit and everything. In the middle of it there was a well.

"I knew it was a well because you could see the water bubbling up from the bottom of it: but it was a lot bigger than most wells—like a very big, round bath with marble steps going down into it. The water was as clear as anything and I thought if I could get in there and bathe it would ease the pain in my leg. But the lion told me I must undress first. Mind you, I don't know if he said any words out loud or not.

"I was just going to say that I couldn't undress because I hadn't any clothes on when I suddenly thought that dragons are snaky sort of things and snakes can cast their skins. Oh, of course, thought I, that's what the lion means. So I started scratching myself and my scales began coming off all over the place. And then I scratched a little deeper and, instead of just scales coming off here and there, my whole skin started peeling off beautifully, like it does after an illness, or as if I was a banana. In a minute or two I just stepped out of it. I could see it lying there beside me, looking rather nasty. It was a most lovely feeling. So I started to go down into the well for my bathe.

"But just as I was going to put my foot into the water I looked down and saw that it was all hard and rough and wrinkled and scaly just as it had been before. *Oh, that's all right, said I, it only means I had another smaller suit on underneath the first one, and I'll have to get out of it too.* So I scratched and tore again and this under-skin peeled off beautifully and out I stepped and left it lying beside the other one and went down to the well for my bathe.

"Well, exactly the same thing happened again. And I thought to myself, *oh dear, how ever many skins have I got to take off?* For I was longing to bathe my leg. So I scratched away for the third time and got off a third skin, just like the two others, and stepped out of it. But as soon as I looked at myself in the water I knew it had been no good.

"Then the lion said—but I don't know if it spoke—*You will have to let me undress you.* I was afraid of his claws, I can tell you, but I was pretty nearly desperate now. So I just lay flat down on my back to let him do it.

"The very first tear he made was so deep that I thought it had gone right into my heart. And when he began pulling the skin off, it hurt worse than anything I've ever felt. The only thing that made me able to bear it was just the pleasure of feeling the stuff peel off. You know—if you've ever picked the scab of a sore place. It hurts like billy-oh but it is such fun to see it coming away."

"I know exactly what you mean," said Edmund.

"Well, he peeled the beastly stuff right off—just as I thought I'd done it myself the other three times, only they hadn't hurt—and there it was lying on the grass: only ever so much thicker, and darker, and more knobbly looking than the others had been. And there was I as smooth and soft as a peeled switch and smaller than I had been. Then he caught hold of me—I didn't like that much for I was very tender underneath now that I'd no skin on—and threw me into the water. It smarted like

anything but only for a moment. After that it became perfectly delicious and as soon as I started swimming and splashing I found that all the pain had gone from my arm. And then I saw why. I'd turned into a boy again. You'd think me simply phony if I told you how I felt about my own arms. I know they've no muscle and are pretty moldy compared with Caspian's, but I was so glad to see them.

"After a bit the lion took me out and dressed me—"

"Dressed you. With his paws?"

"Well, I don't exactly remember that bit. But he did somehow or other: in new clothes—the same I've got on now, as a matter of fact. And then suddenly I was back here. Which is what makes me think it must have been a dream."

"No. It wasn't a dream," said Edmund.

"Why not?"

"Well, there are the clothes, for one thing. And you have been—well, un-dragoned, for another."

"What do you think it was, then?" asked Eustace.

"I think you've seen Aslan," said Edmund.

"Aslan!" said Eustace. "I've heard that name mentioned several times since we joined the *Dawn Treader*. And I felt—I don't know what—I hated it. But I was hating everything then. And by the way, I'd like to apologize. I'm afraid I've been pretty beastly."

"That's all right," said Edmund. "Between ourselves, you haven't been as bad as I was on my first trip to Narnia. You were only an ass, but I was a traitor."

"Well, don't tell me about it, then," said Eustace. "But who is Aslan? Do you know him?"

"Well—he knows me," said Edmund. "He is the great Lion, the son of the Emperor-over-the-Sea, who saved me and saved Narnia. We've all seen him. Lucy sees him most often. And it may be Aslan's country we are sailing to."[4]

The process of scales being removed is a loving process. Do you feel like you're going under? If so, it is something different. I can suffer and still be able to give and receive love. When we choose to carve a different path, one of freedom to walk into more love and life, suffering may be a part of that, but God never asks us to go under. He always desires love and life.

Doing things differently is painful. We prefer the familiar. Like the Israelites, we prefer Egyptian oppression to freedom in the desert wilderness that brings greater challenges to bear. I love how Victor Hugo expresses this in his amazing work, *Les Miserables*—"Thoughtful minds make little use of this expression: the happy and the unhappy... The true division of humanity is this: the luminous and the dark... But whoever says 'light' does not necessarily say 'joy.' There is suffering in the light; an excess burns. Flame is hostile to the wing. To burn and yet to fly, this is the miracle of genius... When you know and when you love, you will still suffer. The day dawns in tears. The luminous weep, be it only over the dark ones."[5] In our sorrow, we are comforted by the God of all comfort, and we are taught how to comfort others through the comfort we have received. We can learn to bless from our own narrative.

What is your creative story? As you look back on your upbringing, in what ways did your family of origin encourage creativity? What was the backdrop for creative learning? What shared values helped or harmed your approach to the creative arts? Did your family enjoy music? Did you take trips to art museums? What was your house like? Do you remember color and texture that brought comfort, smells that made you feel loved? Do you remember how your family responded when you created a play? It will be important to look at these things to ascertain where false beliefs have embedded themselves.

Creative Support

Do you have people in your life who champion your creative discovery? You need to. To be an artist means to belong to community and share with one another without fear of censorship or damaging criticism. Yet if we try to find this acceptance in people and they disappoint us, we despair of community and

what shared values **helped or harmed** your approach to the creative arts?

start to live inside our head. We attempt to create our own safe place away from the pain of letting others in on our struggle. We will have further run-ins with friends and family who shame us, unintentionally or intentionally. It will happen again, and we shouldn't be completely surprised when it does. The question is, what do we do with this? If we can be in touch with and bring Jesus into our grief and sorrow, we are less encumbered by the fear of receiving more arrows. If we are staying in the middle of our belovedness, the applause of men is nice, but not required. If we fix our gaze on Jesus, disdain from men is unpleasant, but not devastating.

Dealing with our pain does another very profound work. Our non-retractable places of sorrow help us to attend to others' sorrow with compassion. When we name our sorrow, we begin to learn to be a safe person for others. We also learn to be wise with whom we share our vulnerabilities. If many people in your life are not supportive, the process of reawakening your creativity will be an additional challenge. Look for those around you who will champion your journey. Guard your heart. There will be tension, especially if someone close—like a spouse—is resistant to the changes. Know that you are moving in the right direction. Tension may increase before relief comes. But stay the course. Surround yourself with those who value your recovery. Protect yourself from abuse. It would be creative injury in this early stage to expose your emerging work to toxic criticism. Protect and defend your childlike artist. This small child doesn't need critique, no matter how innocuous it seems. It already takes a lot to recover from past events. We don't need add new pain to the old wounds right now. Be vigilant and take care as you select those whom you will let in on your creative awakening.

Anger

Anger is a road sign of sorts. It's a caution sign that points to danger lurking underneath the surface. It is not something to be ignored or snuffed out. Anger is widely viewed as a negative emotion; however, emotions are not positive or negative. They just are. They are part of being human. Some of the behaviors attached to certain emotions give them a bad reputation. I was taught that anger

is wrong and should be expunged; certainly not listened to. But the reality of living in our world is that there is a lot to be angry about! The pathway to anger's source seems a mystery, or a map that seems impossible to navigate. To delve into the messages that your anger is sending, write! If you can arrest moments in which you feel strongly, may it be anger, rage, resentment, stress, or any other powerful emotion, write. As you write, you will find yourself getting to the source. Strong emotions invite us to look. Follow the map of your emotions to the origin of what restricts you creatively and otherwise.

Anger is a clue, a very real and valid part of who we are. It's a stray spark from a significant event. It will lead us back to the great explosion that has kept us bewildered. One of the first times I felt grief over my father, whom I haven't seen since I was five, come in a moment of anger many years later. My mom and dad divorced when I was one. When I was four, my mother, brothers and I moved across the country and away from my father. One year later, he came to visit for a week. That was the last time I saw him. He attempted to contact me sporadically through the years, but we never really had any significant exchanges. I did not feel known by him, nor did I know him. It seemed to me to be an indifferent realtionship both ways. As a child and into adulthood, I detached myself from feelings of loss and grief over my father's absence. I normalized it. I learned to say things like, "God protected me from having a bad father," and, "I really don't know him, so I don't feel sad."

One day an ordinary, normal irritation with my husband turned into volcanic spew. Through anger and tears, I started writing … writing and spilling fear, hurt, anger out all over the pages. I followed the map to its conclusion, and can you guess where it brought me? My father was the conclusion that day. I realized after all these years that I had never grieved the implications of his absence. I realized that his indifference profoundly impacted the present. Without realizing it, I had gone through life looking for ways to find significance. If being a daughter wasn't enough, maybe something else would be. But in that moment, instead of normalizing abandonment, I grieved over my father's indifference to me. It wasn't until I witnessed firsthand what a father/daughter relationship was intended to

be (through my husband and daughters) that I started to feel grief. What a map I had to navigate to get to the anger! I had tucked it away somewhere deep in the chambers of my heart. When I finally did follow the map, I was shocked. I am still in the process of discovering and healing, as we all are. Jesus, the Man of Sorrows, would have you follow Him to the source of your sorrow, rather than shoving it down somewhere, and having it come out sideways.

He will bring healing. When you discover the memory, you may ask Him through tears where He was. He is not afraid of your pain or anger. He is not afraid of white-knuckled fists. In order for healing to take place, you must feel these emotions and walk through them to the end. "Be strong and very courageous!" (Joshua 1:7) And remember His desire for you, always, is more love.

The process of entering into the depth of your emotional wounds must be done at the table in the presence of the Lord. In the 23rd Psalm, we hear this invitation to bring our brokenness to the table. Verse 5 says, "You prepare a table before me in the presence of my enemies. You anoint my head with oil; my cup overflows." This verse captures this chapter in two sentences! God prepares a table for you to come with your "enemies" – your self-contempt, your addictions, your pious self-righteousness, your wounds, your sicknesses. He invites you—all of you—the whole of who you are—and prepares a feast in the presence of your poverty. Then, what does this glorious Host do?? He anoints your head with oil and your cup overflows. You are being healed. This is what He does with the parts of you that you may consider "enemies": "I will seek the lost, and I will bring back the strayed and I will bind up the injured and I will strengthen the weak" (Ez. 34: 14-16). When we bring the false self to the table He has prepared, this false self is reconciled with welcome and anointing!

Have you ever said or heard the phrase, "I'm at peace with…"? What does that mean? It's usually after some type of loss or difficult shift in circumstances. We want to get to that phrase so quickly in the grieving process before we've gone through the steps. Don't be at peace with anything too quickly. Does God call us to make peace with the brokenness and poverty of this world? Do we have to be okay with things that are very wrong about the world or our lives? Are we turning

our backs on God if we feel sorrow, loss or pain? It seems that we have reasoned that if God is really good, there must be nothing to grieve about. Yet to grieve means to acknowledge that there are bad things. How do we reconcile bad things in a universe createdby a good God? This question will remain a mystery on this side of heaven. But we do know that God says "yes" in Jesus, meaning that Jesus has come to fulfill God's promises to eradicate death and suffering. Jesus is God's answer for evil and decay. He has more than sufficiently answered the question of death and suffering by entering into it, experiencing it and defeating it. This doesn't mean that no questions remain, or that we feel peace when life has been stolen away. On the contrary, we feel sadness at the destruction of the beauty God intended for the world. How important it is, in light of this great sorrow, to play an active part in the narrative of that which has fallen, being returned to glory by honoring precious loss.

Grieving What's Lost

To accept our creative losses, we must live with and fully accept our reality. Our denial systems must come down. The phrase, "It is what it is," is helpful to me because it reduces life down to the present and the real. It draws me back to a place of reality and stops my mind from straying down the path of embellishing or revising what my life really is. It startles me into truth and exposes the ways I try to fantasize and imagine life other than what it is, moving away from presentness and into some other imagined moment, when what it is feels ordinary and boring. I have Walter Mitty syndrome.

To live and fully accept our reality of loss and grief, Richard Rohr says, "This solution sounds so simple and innocuous that most of us fabricate all kinds of religious trappings to avoid taking up our own inglorious, mundane, and ever-present cross. For some reason, it is easier to attend church services than quite simply to reverence the real—the 'practice of the presence of God,' as some have called it. Making this commitment doesn't demand a lot of dogmatic wrangling or managerial support, just vigilance, desire, and willingness to begin again and again. Living and accepting our own reality will not feel very spiritual. It will

what event has held your
PENCIL CAPTIVE?
what creative losses
have you not yet grieved?

feel like we are on the edges rather than dealing with the essence. Thus, most run toward more esoteric and dramatic postures instead of bearing the mystery of God's suffering and joy inside themselves. But the edges of our lives—fully experienced, suffered, and enjoyed—lead us back to the center and the essence."[6] Jesus says, "…Unless a grain of wheat falls into the earth and dies, it remains alone; but if it dies, it bears much fruit" (John 12:24). Allowing losses to be felt and healed involves a death and a resurrection. The grain of wheat dies and is resurrected again. I saw a moviein which I was reminded of this truth. It's called *Reign Over Me* and it tells the story of a man who lost his wife and three daughters in the Twin Towers tragedy. He reconnects with an old college roommate who never knew his family. When they interact, his friend sees immediately how lost he is and how he has chosen to try to forget. But, in the forgetting, he got lost. To every attempt his friend makes to bring truth to his memory, he responds with rage. It is a sweet story of this man finally walking through the Grey by remembering. He had to surrender to deep pain to find a resurrection. What creative losses have you refused to grieve? What losses does God want to resurrect and bring new life into? You can't change what you don't acknowledge. The first step towards counting your losses is to identify what they are. Why did you stop getting out the guitar? What made you decide not to perform in front of people anymore? What event has held your pencil captive? Acknowledging our losses gives us fleshy hearts rather than stony ones. When our hearts become like flesh, we grieve over time lost. Honor your precious loss.

I want to encourage you that God will turn your mourning into dancing! It is appropriate to have a time of grief for these losses you've identified. Take some time to feel the reality of the pain, yet I caution you not to get stuck in the grief. God is committed to bring redemption and to "restore the years the swarming locusts have eaten" (Joel 2:25). God alone can bring that kind of hope to your grieving heart.

Sometimes our creative wounds serve as the severe mercy of God. Creative bruises and injuries can be catalysts for our surrender. As we learn to bring

form to our creative image-bearing, we learn that our connection with Jesus is closely tied to what we create. As we learn what it means to surrender our fears (most likely born out of our wounds) and hear what God wants to tell us, there is room to fail. How do we fail successfully? We all have failed on this road fraught with peril. Do we characterize failures as "magnificent defeats and life-enhancing failures"?3 As we bring disappointing and devastating moments under the gaze of God, we find a true Friend. As we sit in the silence of His presence, we find tender kindness without shame. The fight may bloody us, but we can grieve, be refreshed by His gracious love, and then return to the battle. And, we must return! We can only return when we've been into the Grey and Jesus has met us in that place. We have viewed, received and accepted our own poverty and have seen Jesus view, receive and accept that same poverty.

Our failures do not define us. Brennan Manning says, "When I draw life and meaning from any source other than my belovedness, I am spiritually dead."3 What failures are still waiting to be grieved in the presence of the Lord? What failures have caused you, even for a moment, or for several years, to be reinvented? Maybe you experienced failure in a live performance; therefore, you must not truly be a performer. You reinvent yourself and design a person who cannot fail. You put performing down because you're "too busy" and move on to something innocuous or perhaps something perceived as more valuable like organizational skills or household management. But your heart still aches when you see a moving performance. You have managed to shove the way God made you out to the margins. When we come back to the center of ourselves and see that God is present there, it is then that we get back in touch with and embrace how He has made us. The result is connecting with old grief and longings. Our belovedness in Jesus will propel us into risky propositions because in the security of His presence, we transcend our success and failure. They do not have power over us because we are "hidden with Christ in God" (Colossians 3).

Emerging Creativity

Letter to the Impostor:

To: Scared, Complacent Artist
From: Inspirationally Deprived Life Participant

Your selfish fears, Artist, have kept us from mourning over your photos capturing true heartbreak, from humming along to melodies that infuse our spirits with unexplainable joy, from silently screaming "Yes!" to words you penned while battling disgust over mediocrity. Believing lies has kept you from inspiring the silver-haired beauties to reach down, the busy grownups to slow down, and the young to never back down.

Remarkable, soul-stimulating artist, when you quit, you steal growth, change, and opportunity from our world. Say Yes! Dirty the canvas, scribble and stain the pages with your ink, plunk the ivories till they ring, "waste" the film, fall, twirl, leap, trip. Burn the midnight oil to get that final touch just right.

Brave, confident Artist, we give you permission to do fifty takes only to keep one, to take classes, to make the time. Learn new techniques and infuse life experiences, because when you grow, I grow. I follow where you lead and settle where you settle. If you choose to cower behind your safe, comfy fears, then be prepared, Artist, to be blown away by the screaming rocks.

Letter to the Impostor / © 2008 Brianna Wilcox / Used with permission

QUESTIONS FOR REFLECTION

Day 1: Go back into the Grey and choose a time that you remember whenyou felt bruised creatively. In your journal, describe the events, people, and places involved. Remember everything you can about it. Record the details in your journal.

Day 2: Write a letter to the person(s) who injured you. (Not to send it, necessarily.)

Day 3: Invite Jesus into the scene. What truth does He want to speak to you concerning this wound? Lean in and listen closely to what He is saying to you. To retrieve your creativity, you must let Jesus come nd tell you where you have believed a lie.

Day 4: How has this event led you to believe something false about yourself? Grieve the event; allow Jesus to grieve with you. Begin to exchange the lie for the truth. Let love spill into this place of shame.

Day 5: What would change if you were able to embrace the truth of your belovedness and live out of it?

Day 6: What is your pearl of great price?

Day 7: How would it look for you to authentically embrace the calling to create?

SOLITARY PERUSINGS:
WRITE A LETTER TO YOUR IMPOSTOR

In order to move out of the Grey, we must move through it. There is no way around it, over it, or above it; we must lean into it. Write a letter of acceptance to your poverty-stricken self, your impostor. I have included Brennan Manning's letter to his impostor self as an example:

Good morning, impostor. Surely the cordial greeting surprises you. You probably expected, "Hello, you little jerk," since I have hammered you from day one of this retreat. Let me begin by admitting that I have been unreasonable, ungrateful, and unbalanced in my appraisal of you. (Of course, you are aware, puff of smoke, that in addressing you, I am talking to myself. You are not some isolated, impersonal entity living on an asteroid, but a real part of me.)

I come to you today not with rod in hand but with an olive branch. When I was a little shaver and first knew that no one was there for me, you intervened and showed me where to hide. (In those Depression days of the thirties, you recall, my parents were doing the best they could with what they had just to provide food and shelter.)

At that moment in time, you were invaluable. Without your intervention I would have been overwhelmed by dread and paralyzed by fear. You were there for me and played a crucial, protective role in my development. Thank you.

When I was four years old, you taught me how to build a cottage. Remember the game? I would crawl under the covers from the head of the bed to the footrest and pull the sheets, blanket, and pillow over me—actually believing that no one could find me. I felt safe. I'm still amazed at how effectively it worked. My mind would think happy thoughts, and I would spontaneously smile and start to laugh under the covers. We built that cottage together because the world we inhabited was not a friendly place.

But in the construction process you taught me how to hide my real self from everyone and initiated a lifelong process of concealment, containment, and withdrawal. Your resourcefulness enabled me to survive. But then your malevolent side appeared and you started lying to me. "Brennan," you whispered, "if you persist

in this folly of being yourself, your few long-suffering friends will hit the bricks, leaving you all alone. Stuff your feelings, shut down your memories, withhold your opinions and develop social graces so you'll fit in wherever you are."

And so, the elaborate game of pretense and deception began. Because it worked I raised no objection. As the years rolled by, you-I got strokes from a variety of sources. We were elated and concluded the game must go on.

But you needed someone to bridle you and rein you in. I had neither the perception nor the courage to tame you, so you continued to rumble like Sherman through Atlanta, gathering momentum along the way. Your appetite for attention and affirmation became insatiable. I never confronted you with the lie because I was deceived myself.

The bottom line, my pampered playmate, is that you are both needy and selfish. You need care, love, and a safe dwelling place. On this last day in the Rockies my gift is to take you where, unknowingly, you have longed to be— into the presence of Jesus. Your days of running riot are history. From now on, you slow down, slow very down.

In His presence, I notice that you have already begun to shrink. Wanna know somethin', little guy? You're much more attractive that way. I am nick-naming you "Pee-Wee." Naturally, you are not going to roll over suddenly and die. I know you will get disgruntled at times and start to act out, but the longer you spend time in the presence of Jesus, the more accustomed you grow to His face, the less adulation you will need because you will have discovered for yourself that He is Enough. And in the Presence, you will delight in the discovery of what it means to live by grace and not by performance.

Your friend,
Brennan[6]

WAKING UP *grey*

She dabbled today. She felt a new sense of freedom, knowing the Master would delight in her playfulness. He had given new dignity that enabled her to find joy in what she loved. Her grandfather's potter's wheel that he gave her as a teenager was up in the attic. She hadn't made a mess in years, but after much trepidation and thinking and rethinking, she finally brought it down. It was pretty old and worn. After procuring a couple of new parts from the hardware store and spending some frustrating moments trying to make it work, she set off. Of course, she had to put newspapers down. "If I'm going to make a mess, it should be contained and easy to clean." She sat down at the wheel and prayed. She submitted to her Master, who was to lead the exploration. As she let her hands fall into the wetness and texture, she thought about God as a creator and what thoughts went into molding her. What was He thinking as He was making? Did He have plans beforehand, or did she simply emerge? Did He delight in the process? Did He delight in His work? As she began to form a pitcher on that wheel, she started to understand what time, thought, and love went into creating her. The wheel became an altar where she worshipped in the throne room of God.

five

SELF-CARE

Child-like Nurturing

This chapter is all about you! Are you okay with that? You need to be okay with that. Many religious people hold the view that self-care, a healthy self-image, counseling that focuses on self, etc., is not biblical (at worst) or navel-gazing (at best). Somehow, our theology equates self-loathing with humility. That is not true humility! If you want to do good for others, you must not be a stranger to what good feels like. Operating out of our belovedness must become second nature to us. We spend much of our early years groping for who we are. We learn to comply with what we're told we should, ought and need to be. Somewhere along the learning, we abandon our selves and who God intended this "self" to be. This knowledge needs to be recaptured and can only be found in Jesus. We are hidden with Christ in God. He is holding that lost self for us. He has kept it and He alone can tell us what that looks like. As

what would
child-like play
look like for you?

we engage in the solitude and sit with Jesus, He will open that treasure jar and begin to define who you are. This identification: you, as His beloved, will be the crux of your daily operations. The altars that you place around the daily-ness of life will be full of aromatic worship because your moments will be full of the knowledge that you have been hidden with Christ in God. This is where your true identity lies!

Nurturing starts with a yearning to know this person whom God has gone to great lengths to fashion, create and then to redeem! What would child-like play look like for you? What would it do for you? Can you identify the last time you did something child-like? Where did it lead you? What were your dreams as a child? When adults asked what you wanted to be when you grew up, what was your answer? When did you abandon your dreams? Look back to when you were a child to see what your child-likeness would be. I wanted to be a figure skater when I was little. For me, one way to experience child-like play means spending time on the ice.

A delight of being with Jesus is becoming acquainted with yourself. You don't know yourself as well as you think you do. But Jesus is the gatekeeper of your soul. He knows the answers to all of the questions you have about yourself. One week, during a group discussion, I posed this question to the group: "How do you experience self nourishment?" Dead silence... I waited a while for answers to come. For a lot of us, this question remains a mystery. We have not cared for ourselves enough to even begin to know the answer. The answer would simply be, "I don't know." And that answer is okay... for now. But I would challenge you to approach the table and ask the Shepherd about yourself: What do I love? What makes me feel cherished and celebrated? What is nourishment to me? What helps me give and receive love? You may be able to answer right away. You may have no idea. But finding out is a clue to discovering more about yourself. There is One who knows the answer if you don't. Ask Him. Whatever the answer is, you need more of it in your life!

Looking More Like Jesus

"And to put on the new self, created after the likeness of God in true righteousness and holiness" (Ephesians 4:24). What does your new self look like? "After the likeness of God." We are perfectly acceptable before God. He is perfectly at peace with us because of Jesus. The wrath of God was satisfied in Him. But we groan and there is a tension, like that of a bow gliding across the strings of a violin. Jesus applies the tension to bring about a beautiful, haunting melody. It is in the becoming that life and melody are found. So, although not yet perfected or glorified, we can endure His gaze.

Jesus summed up the law in two commandments: "Love the Lord your God with all your heart, soul, mind and strength. And love your neighbor as yourself." If we look closely at this, we see that loving your neighbor as yourself presupposes that you have loved yourself. Would your neighbor feel loved by you if you actually loved them the way you have loved yourself? I have noticed that it is completely acceptable in our communities to speak in disparaging ways about ourselves, ways in which we would never speak about another. Why is this okay? How do you love yourself? How would you answer the following questions?

- In what ways do I love well?
- What are my strengths?
- What are my gifts?
- How have I made a godly, beautiful impact on those I love?
- How has the beauty of Jesus flowed from me to others?
- How am I worthy of love?
- Who loves me?
- Who has given of themselves for my good?

Was it hard to answer these questions? Did it feel extravagant to say gracious things about yourself? Now answer these questions about someone you respect and love. Was it easier or harder? Now consider how Jesus would

answer these questions about you. Write down what He would say about you. The practice of loving yourself is not meant to puff up. Rather, acknowledging our standing with Jesus will bring true humility. As you listen to what Jesus says about you, allow yourself to be captivated. Be taken with His beauty and how well He loves you. He doesn't love you for your performance. He loves you for the very fact that you are His. Anthony A. Hoekema, author of *Created in God's Image*, says the "Christian self-image, when properly understood, is the opposite of spiritual pride. It goes hand in hand with a deep conviction of sin and a recognition that we are still far from what we ought to be. It means glorying not in self but in Christ. It includes confidence that God can use us, despite our shortcomings, to advance His kingdom and to bring joy to others."[1] Self-care is imperative. Yes, this is about you... it has to be for a time. Recovering parts of yourself is good for you and those around you. If you've left yourself depleted, you can't take care of anyone. You can't choose the martyr road anymore.

Being Attentive To God's World

How much do we miss by simply not tending to the moment?! Being dutiful squanders any capacity to pay attention. I experience this every day as I care for my children. The view of their beautiful faces disappears behind the laundry pile. Their laughter is drowned out by the sound of running water and clanking dishes. Julia Cameron, in her book *The Artist's Way*, says, "The quality of life is in proportion, always, to the capacity for delight. The capacity for delight is the gift of paying attention."[2] What do you delight in? What brings you pleasure? What captures your attention? If you do not know, it is time to find out.

Being attentive is different from being distracted. Have you ever experienced the seduction of our Lover when He lures us away from our distraction into a moment full of beauty? I live for those moments! Sometimes I'm too distracted to see when they are happening, so I urge you to be attentive to moments when Jesus invites you to the table. Be willing to come away and partake. Paying attention means we may end up taking big detours. Paying attention means being willing to follow the Shepherd's voice. Today, He may be leading you into a

grander pasture than yesterday. Put your agenda and lists down and use the map of His voice as He orders your steps. To be attentive to the world is invitational. Accept the invitation and look receptively.

In the last few years, I have taken up some spiritual disciplines. These create more spaces in my life for wonder and astonishment. One of my disciplines is the practice of gratitude. I ask myself two questions each night before I go to sleep. The first question is, "What am I grateful for?" I review my day and relive the things I'm grateful for. Sometimes they are big events. Sometimes I think about the hundreds of people that contributed to make my life what it is. The hands that grew the plants that showed up at my table, the people who shipped the wheat to the factory that turned ingredients into cereal. The people that wired my house to carry electricity to the lightbulb so that when I flipped a switch my room illuminated with light. The people who dig trenches to install pipes so that when I turn on the faucet I have clean, running water. And on, and on. Gratitude goes micro and macro.

The second question I ask is, "What am I not so grateful for?" These two questions give us some context for how we experience God in our days. What are you grateful for? Where have you seen God today and given and received love? Put more of that in your life. What are you not so grateful for? Where have you missed God and where have you been drawn away from life and love? Put less of that in your life. These two questions were adapted by Fr. Matthew Linn from the Ignatian Examen.

Come and Eat
Does God have dreams for you? What do you believe He thinks about you? What are His desires for you? Does He want more love and life for you? Hear His desires for you in the following passage:

Come, everyone who thirsts, come to the waters;
and he who has no money, come, buy and eat!
Come, buy wine and milk without money and without price.

Why do you spend your money for that which is not bread,
And your labor for that which does not satisfy?
Listen diligently to me, and eat what is good,
And delight yourselves in rich food.
Incline your ear, and come to me;
Hear, that your soul may live;
And I will make with you an everlasting covenant. (Isaiah 55:1-3)

It is an act of worship to accept these words and believe the Living God has invited us to a feast. That He would use this poetic description and appeal to our senses—a table full with the richest of fare—says so much about His heart. This passage turns any notion we have of a miserly God upside down. What is keeping you from accepting this dinner invitation? "Hear, that your soul may live"… the very words that proceed from the mouth of God are food for the soul! He has made us to desire good things. He has made us with strong sensibilities… it is how He speaks to us. His gifts are not monetary. His generosity isn't measured in dollars, although blessings sometimes manifest in monetary value. His generosity becomes our delight as we listen diligently and eat what is good. His generosity is very different from ours. What we perceive as "blessing" often brings sorrow; and what we perceive as "sorrow" often serves as our redemption. What a mystery.

Intricate Weavings

There is no room in our creative process for comparing our work with others. Not only is it inappropriate, it is harmful and unproductive. God has uniquely created you. There are no duplicates. You are the only one capable of being you. You are the only one with the specific callings, gifting and abilities that make up who you are. And these are intertwined with your unique experiences and personality. There is no one else called to be you. Measuring yourself against another is therefore a futile exercise. You have no standard by which to measure, since there is nothing that even comes close to being you. God did not intend for you to be like your sister-in-law or your best friend. He intended you to be like

you, who SHOULDN'T look like anyone else. And trying to be like someone else does a real disservice to the journey you're on.

The cure for comparing yourself to others lies in your belief that you are fully accepted in the Beloved. Do you believe you are fearfully and wonderfully made? Can you release yourself into what that means? Can you rest in the knowledge that you have been made exactly as He sees fit? The more you can rest in this truth, the more comparing yourself to others will become obsolete. It just doesn't make sense in light of the truth of Psalm 139.

> *O Lord, you have searched me and known me!*
> *You know when I sit down and when I rise up;*
> *You discern my thoughts from afar.*
> *You search out my path and my lying down*
> *And are acquainted with all my ways.*
> *Even before a word is on my tongue,*
> *Behold, O Lord, you know it altogether.*
> *You hem me in, behind and before,*
> *And lay your hand upon me.*
> *Such knowledge is too wonderful for me;*
> *It is high; I cannot attain it.*
> *Where shall I go from your Spirit?*
> *Or where shall I flee from your presence?*
> *If I ascend to heaven, you are there!*
> *If I make my bed in Sheol, you are there!*
> *If I take the wings of the morning*
> *And dwell in the uttermost parts of the sea,*
> *Even there your hand shall lead me,*
> *And your right hand shall hold me.*
> *If I say, 'Surely the darkness shall cover me,*
> *and the light about me be night,'*
> *Even the darkness is not dark to you;*

The night is bright as the day,
For darkness is as light with you.
For you formed my inward parts;
You knitted me together in my mother's womb.
I praise you, for I am fearfully and wonderfully made.
Wonderful are your works;
My soul knows it very well.
My frame was not hidden from you,
When I was being made in secret,
Intricately woven in the depths of the earth.
Your eyes saw my unformed substance;
In your book were written, every one of them,
The days that were formed for me,
When as yet there were none of them.
How precious to me are your thoughts, O God!
How vast is the sum of them!
If I would count them, they are more than the sand.
I awake, and I am still with you.

This is God's word! This beautiful poetry is the truth about you in light of our God! As we let the truth of these words settle into our hearts, we realize that we were never meant to be like a cheap knock-off of someone else. The band Coldplay writes, "God gave you style and gave you grace, and put a smile upon your face." And it was intended for you and you alone.

My friend Angela took the photograph found at the beginning of this chapter of a garden gate in Charleston, South Carolina. It has always looked like an invitation to me. It reminds me of John 10:9. Jesus is talking about His sheep when He says, "I am the door. If anyone enters by Me, he will be saved and will go in and out and find pasture." What is pasture for a sheep? It is beauty, nourishment, rest, safety, fellowship. Jesus, as the door keeper, invites us into His pasture for rest and play! What is He asking you to do? Do you believe you

are important to Him? Do you believe you matter to Him and that He wants rest and nourishment for you? He is inviting you to come out to pasture and be refreshed. In Revelation 3:20, Jesus again offers an invitation: "Behold, I stand at the door and knock. If anyone hears my voice and opens the door, I will come in to him and eat with him and he with Me." What an invitation from our Lord! Are we as eager to receive as He is to give? Why or why not?

Emerging Creativity
"Not Ready to Fly"

Three dead birds on the sidewalk make me weep
Not yet old enough to have feathers
To fly away from gravity
To escape the force that meant their end

Would that they had lived long enough
To strengthen their wings!
To keep receiving food from mother
With wide open beaks
To chirp and chatter at the morning sky
And be baby birds until it was the right time to leap
But it was not their time

And so do I weep?
Do I wait for my time?
Or do I leap while still I have no feathers
Nor strength to fly?
Will I be content to stay in this nest until it is my time?

Lauri Newell / © July 2009 / Used with permission

QUESTIONS FOR REFLECTION

Day 1: What is nourishment for you? How often do you experience this? Ask God how you can experience more of this with Him. If you're not sure what the answer is, ask Him the question and wait for His answer.

Day 2: Does God care about the way you take care of yourself? Why or why not?

Day 3: Give some thought to what God was thinking in His design for you. According to Psalm 139, His thoughts were vast. What do you think He was thinking about? According to this passage, what would He say to our assumptions that He is neutral to our expression of creativity?

Day 4: Why do you think God would appeal to our senses? Why would He use the metaphor of "rich food"?

Day 5: How does this happen "The cure for comparing yourself to others liesin your belief that you are fully accepted in the Beloved."

Day 6: How would loving yourself well translate to more creative freedom?

Day 7: How would duty kill and destroy any nurturing or care of yourself?

SOLITARY PERUSINGS

You don't need your journal today. But, here's what you need:

- A large piece of illustration board, watercolor paper or poster board (can be found at any art store or craft store)
- Glue
- Scissors
- Images (from magazines, cards, printed paper, images you create yourself by drawing, painting, photography, etc.)

Find several images that "scream" nourishment to you. If you don't know what nourishment looks like for you, this will help sort it out. Glue these images to the board and make a "care collage."

WAKING UP *grey*

She brought a new set of fears to the table today. When she showed the new pitcher to her mother, the same thoughts and feelings as the last time came flooding in. It was back when she first received the potter's wheel from her grandfather. She was so excited and immediately wanted to learn how to make beautiful things on it like her grandfather did. Her grandfather sat down with her over the next several months and showed her how to be a pottery artist, like he had been before his arthritis prevented him from turning any more pieces. Oh how her grandfather praised anything and everything that came off that wheel. Her mother, not understanding the art, and fearful that her daughter would not attend college, disdained any piece of work that Grey worked up the nerve to show her. Shortly after her grandfather died, and after one too many criticisms from her mother, she put the potter's wheel away and attended college, but never forgot about the wheel. Her mother was the same as she ever was; she condemned what she didn't understand. But Grey was different today. She came to the table in grief, but not in resignation or despair. She loved her pottery. She was asked by a local artisan shop if they could sell her pieces. She was still afraid, but knew the Master had given her the pearl of great price to guard. She walked through the fear into handing over her pieces to the shop.

six

MOVING THROUGH FEAR

False Beliefs

I want to warn you that this is not a safe chapter! But it is a chapter of freedom! God's ways don't promise safety on this earth. "After all, He is not a tame lion!" (C.S. Lewis, *The Lion, the Witch and the Wardrobe)* There will always be an element of danger where the Great Warrior is involved. That must be why "Do not fear" is the most repeated command in the scriptures. This would presuppose that very real dangers exist. Rather than operating out of fear, our Lord would have us be liberated. Danger lurks, but we can learn how to create with freedom. Let's discover further what is keeping us from moving more fully into our creativity. Fears are closely tied with false beliefs we carry about ourselves, others and God. Various things happened in the past to forge our fears. Our faulty belief system interprets these things and the fruit is fear. If we name our fears, we may learn to operate from a profound place of freedom. We will always carry fear, but it will have less power over us. Fear is needed because

there are very real dangers. But, we come to believe that some things are worth risking even in the face of fear. We step out in faith when courage is louder than our fears because we have shifted from a belief that is false toward a true belief.

Let's consider the following fears:

- I am not worthy of love.
- Others will be upset with me (I will not please people).
- I will lose control.
- I will become self-absorbed.
- I am incompetent.
- I am a failure.
- I will be abandoned.
- I will uncover ungodly desires.
- I will be embarrassed or exposed.
- I will lose my comfort and security.
- I will turn to my addiction.
- I could die.
- I am not worthy of success.

Which of these fears resounded in your heart? Check all that apply. What false beliefs are behind these fears?

The voice of false humility is often heard when you consider yourself an artist. Julia Cameron, in her book, *The Artist's Way*, says, "We could wonder and worry about our arrogance instead of being humble enough to ask for help to move through our fear."[1]

It is arrogance that keeps us from asking for help. True humility would seek wisdom. False humility therefore must be rooted in fear and pride. Intentionally asking Jesus for help puts you "on the hook" of responding, believing and attempting to create. Failing to acknowledge His delight in your creativity gets you "off the hook," of trying to create. If we really believe that He intends our

freedom and delights in it, what would that free us up to do? It would certainly free us up to understand Him better as well as ourselves. Do we really want to know ourselves and God, or is it easier to be estranged from ourselves and God? This is the root of the question Jesus poses to the man at the Bethesda pool in John 5. "Do you want to get well?" Jesus has a way of cutting through the externals to see into the deep places of the soul and invites us there to see as well. He is always asking us the poignant question that needs asking. His questions help to remove obstacles for those who really desire intimacy with God.

Our freedom from fear must begin with becoming people who are God-aware and self-aware. In this text, we have experienced some freedom in learning to be more aware of God in our solitude. It is also in this time that we will learn to be more self-aware. The following is a list of motivations adapted from Enneagram personality types.[2] Which one grabs your attention?

1. To be right, to have integrity and balance, to strive higher and improve others, to be consistent with ideals, to justify yourself, to be beyond criticism so as not to be condemned by anyone.
2. To be loved, to express feelings for others, to be needed and appreciated, to get others to respond to you, to vindicate claims about yourself.
3. To feel valuable and worthwhile, to be affirmed, to distinguish yourself, to have attention, to be admired, to impress others.
4. To be yourself, to express yourself in something beautiful, to find the ideal partner, to withdraw to protect your feelings, to take care of emotional needs before attending to anything else.
5. To be capable and competent, to master a body of knowledge and skill, to explore reality, to remain undisturbed by others, to reduce your needs.
6. To have security, to feel supported, to have the approval of others, to test the attitudes of others toward you, to defend your beliefs.
7. To be happy and satisfied, to have a wide variety of experiences, to keep your options open, to enjoy life, to amuse yourself, to escape anxiety.

duty kills
HOPE, JOY AND LOVE.
what do you do that is
driven by duty?

8. To be self-reliant, to resist weakness, to have an impact on the environment, to assert yourself, to stay in control, to prevail over others, to be invincible.

9. To have serenity and peace of mind, to create harmony in your environment, to preserve things as they are, to avoid conflicts and tension, to escape upsetting problems and demands.

You may identify with more than one on the list, but I want you to pick the one that best describes you. In general, your fears are rooted in those things that threaten your core motivations. Understanding what you want is the key to understanding your basic fears. We'll look at this more closely below.

Distractions

Distraction is a powerful allurement that derails important work. We choose things we feel a duty to; things we "should" do that distract us from the higher road. Duty kills hope, joy and love. What do you do that is driven by duty? What distractions are you keeping in place? What is the payoff? What is the fear? Distractions are difficult to identify because they may be necessary and good. But are they always the best choice? Are you spending a disproportionate amount of time on these distractions? I am in the middle of studying for an exam that is scheduled to take place in a couple of weeks. Returning to school is a large part of my *Waking Up Grey* experience. It is important to me. For me, in this season, it is the higher road. When I set aside a block of time to study, I find myself letting it whittle away as I fiddle on the computer or put a load of laundry in the washing machine or clean up from the breakfast flurry. I have found that I have to leave the house and go to a quiet place to study where my extraneous work is not luring me away from what I need to be focused on at the time. Time spent in reawakening creativity is time well spent. The more we acquiesce to distraction, the less we believe in the value of creating. Distractions crowd out the process. In our busy, task-driven culture, carving out room for this process is especially difficult. The distractions will

become almost obnoxious. But attending to creativity is the higher road. Let the dishes go. Call on other family members to carry more of the load. It is okay to ask for help. Don't hear me say that family is a distraction or that ditching the many other callings that give form to God's glory is the answer. The difficulty of distraction is sorting through the calling of the moment. It is very easy to fill carved-out time for creativity with other activities. The laundry will suddenly be an urgent issue as you think about sitting down to sketch out a concept that's been floating around in your head. The lure to pick up the ringing phone will become a staunch competitor to penning that story. It is in these moments that we must really understand the value God has placed on the creative process. If we don't believe He has intended this time for a creative purpose, we will not guard it. The things that press around the edges, vying for our time and attention, will not relent. We must say no to other things to be fully present in our creative callings and to learn to tame the urgent. Allow your creative process to be urgent, earning the right to your attentiveness.

The Mystery of Faith

We must take up our faith in place of sabotage. We must look to the city that God is preparing for us even now. Sometimes in the awakening, the journey will seem like foolishness. In difficult moments of waking up, we will hear urgent voices calling us to return to old, dead ways; ways that are familiar. Do not be fooled by these attractive voices. There is a better country than that which you have left! "These all died in faith, not having received the things promised, but having seen them and greeted them from afar, and having acknowledged that they were strangers and exiles on the earth. For people who speak thus make it clear that they are seeking a homeland. If they had been thinking of that land from which they had gone out, they would have had opportunity to return. But as it is, they desire a better country, that is, a heavenly one. Therefore God is not ashamed to be called their God, for he has prepared for them a city." (Hebrews 11:13-16) This passage speaks directly to self-sabotage! When we have made movement and our faith manifests in concrete realities (and we experience some success), the

urge to return to the shadows and remain invisible may become strong. In faith, you have responded to an unseen conviction. You have heard and responded to His voice telling you that you are following Him, and to continue going toward the sound of His voice. Looking back to the land from which you came, you can see brown hills and dry stream beds—a weary and desolate place. Up ahead are green pastures and flowing water, full of life and beauty and color. The journey from here to there involves toil and rest, darkness and brilliant light. You are operating out of the knowledge that God has prepared for us a city!! We are not there yet. We are in the redemptive period of history. God is reviving things that have been dead. Whereas you seek to return to the dry and weary land, God calls you further up and further in. Will you press through by faith and not return to the shadows of the barren land?

Faith carries with it irrationalities! Faith carries us in strength. Brennan Manning writes, "How does the life-giving Spirit of the risen Lord manifest Himself on (difficult) days? In our willingness to stand fast, our refusal to run away and escape into self-destructive behavior. Resurrection power enables us to engage in the savage confrontation with untamed emotions, to accept the pain, receive it, take it on board, however acute it may be. And in the process we discover that we are not alone, that we can stand fast in the awareness of present risenness and so become fuller, deeper, richer disciples. We know ourselves to be more than we previously imagined. In the process we not only endure but are forced to expand the boundaries of who we think we really are. 'The mystery of Christ is among you, your hope of glory'. (Colossians 1:27). Hope knows that if great trials are avoided great deeds remain undone and the possibility of growth into greatness of soul is aborted. Pessimism and defeatism are never the fruit of the life-giving Spirit but rather reveal our unawareness of present risenness."[3] Pastor, Scotty Smith always says in response to the darker side of humanity, "You're better than that." I think Manning is saying the same thing. It is when we choose faith over fear that we are most in touch with our own humanness; yet, we become more God-like than we ever thought we could be.

Doubt

Don't be condemned by doubt; instead, try exploring it. Doubt is not the opposite of faith. (The opposite of faith is cynicism or the contemptuous disbelief in God's goodness). Peter Abelard said, "Doubt is the shadow cast by true faith." Where does doubt concerning our creative journey come from? Our essential suppositions may go something like this: I want to matter. *I want to impact my world.* The questions that follow would include:

Do I matter?
Can I impact this world for good?
Am I going in the right direction?

These are questions worth pondering with Jesus. If we attend these questions and start to find answers, we find affirmation that God is deeply and intimately involved in our wranglings. Sometimes we think of Him as being cooperative with our little escapades rather than the One who has called us into a higher process. We have been called, ordained and invited, and loved into it. "For we are his workmanship, created in Christ Jesus for good works, which God prepared beforehand, that we should walk in them" (Ephesians 2:10). All things are held together by Him. Every good and perfect gift comes from Him.

Read this remarkable passage by Dan Allender. I believe, as he would suggest, that doubt explored brings us to a deep and abiding trust. Doubt is part of the human condition. So, if you're human, you've doubted. We spend much of the time trying to hide that fact from God. But, as we wrestle with God, like Jacob, we find the wrestling to be a means through which our faith is strengthened and our trust becomes substantial:

"Do I believe that God is a loving Father who is committed to my deepest well-being, that He has the right to use everything that is me for whatever purposes he deems best, and that surrendering my will and my life entirely to Him will bring me the deepest joy and fulfillment I can

know this side of heaven? We need to consider again what is and is not biblical trust. Most assume that trust is quiet, serene, selfless dependence on God. Though there is an element of truth to that view of trust, more often than not such serene faith is a by-product of wanting very little from God. It is frighteningly easy to appear trusting when in fact one is simply dead (in denial of the wounds, hunger or struggle of the heart).

Genuine trust involves allowing another to matter and have an impact in our lives. For that reason, many who hate and do battle with God trust him more deeply than those whose complacent faith permits an abstract and motionless stance before Him. Those who trust God most are those whose faith permits them to risk wrestling with Him over the deepest questions of life. Good hearts are captured in a divine wrestling match; fearful, doubting hearts stay clear of the mat.

The commitment to wrestle will be honored by a God who will not only break but bless. Jacob's commitment to wrestle with God resulted in the wounding of his thigh. He would never again walk without a limp. But the freedom in his heart was worth the price of his shattered limb. The price of soul freedom is the loss of what has been deemed most secure (the tight grip over one's soul, the commitment to be one's sole provider and protector) but is intuitively known as no security at all."[4]

This choosing, this buying the pearl of great price will draw us into battle. What would compel us to choose that pearl? The same thing that would compel us to take the red pill and not the blue (for you *Matrix* fans)—because we want to fight. It brings to mind one of my favorite movies. There is a scene in *Lord of the Rings: The Two Towers* in which one of the heroines (Eowyn) is preparing for a war she aches to fight in. Her sword is unsheathed. She is singularly focused on the approaching battle. The future king recognizes Eowyn for her true identity as royalty: "You're a daughter of kings, a shield maiden of Rohan." When we make a choice to invest talents rather than bury them, our true lineage unites with our

longing to fight for and defend the King. Others recognize us and say, "I know you; you belong to the King of a distant land." With that recognition comes deep joy and deep sorrow, as it did for our King.

A common faulty Christian world view is that God's blessings are directly proportional to our righteousness. In our attempt to control God, we expect gifts in accordance with our obedience. Then, when He answers our prayers differently from our expectations, we become demanding and obstinate. My friend Karen likes to call these "magic tricks." We expect God to do a miracle. When He doesn't, we muster up more faith and try to be more obedient. We cannot manage God. He is wild and dangerous and will not conform to our attempts at taming Him. Love is wild and fierce and extends the boundaries of reason. There is mystery in His sovereignty. Why does He sometimes deal with me in such extravagant ways while at other times it seems that I am haggling for every crumb I can grab? These things will remain a mystery. What I do know is that through faith, He has given us what we need to receive answered prayer. Is our faith large enough that when our prayers are not answered in the way we expect that we can still trust the that is being worked out?

Resources

We handle money every day. What directs our stewardship? There's never been a time in my life when I've had extra money lying around waiting to be told what to do. Neither have we, as a married couple, been faithful 10% tithers. As we are moving toward more consistent and intentional stewardship, we are finding, as with many other areas of life, that our trust is spreading out. As it is with our creativity, so it is with our pocketbooks. As we begin to do crazy things, like writing a check to fund a mission trip, or taking a drawing class, or taking an hour to be still before the Lord, we find that our trust in Jesus expands. In fact, we find that not only is He for us, but He has entrusted to us all that we have, whether the gift is extra cash, musical ability, listening skills, the ability to describe something using beautiful words, so that we build one another up. It takes unrelenting, fierce trust to move out creatively and take action. Then, as

we take action, our trust becomes all the more rooted in our hearts. Listen to the story Jesus told in Luke 16:1-8 of the crafty steward:

> "Jesus said to his disciples, 'There was once a rich man who had a manager. He got reports that the manager had been taking advantage of his position by running up huge personal expenses. So he called him in and said, 'What's this I hear about you? You're fired. And I want a complete audit of your books.' The manager said to himself, 'What am I going to do? I've lost my job as manager. I'm not strong enough for a laboring job, and I'm too proud to beg. Ah, I've got a plan. Here's what I'll do… then when I'm turned out into the street, people will take me into their houses.' Then he went at it. One after another, he called in the people who were in debt to his master. He said to the first, 'How much do you owe my master?' He replied, 'A hundred jugs of olive oil.' The manager said, 'Here, take your bill, sit down here—quick now—write "fifty." 'To the next he said, 'And you, what do you owe?' He answered, 'A hundred sacks of wheat.' He said, 'Take your bill, write in "eighty." 'Now here's a surprise: The master praised the crooked manager! And why? Because he knew how to look after himself. Streetwise people are smarter in this regard than law-abiding citizens. They are on constant alert, looking for angles, surviving by their wits. I want you to be smart in the same way—but for what is right—using every adversity to stimulate you to creative survival, to concentrate your attention on the bare essentials, so you'll live, really live, and not complacently just get by on good behavior." (*The Message*)

This is shocking. I don't recall hearing this parable in Sunday school. Sometimes it's hard to know what to do with those red words threaded throughout the New Testament. I love that Jesus breaks through our deeply conditioned notions of Divine behavior. Love breaks the stringent rules we've put down. John Shea says the following about this parable: "The unjust steward who, hearing

he is going to be fired, doctors his master's accounts to secure another job, is commended precisely because he acted. The point does not concern morality but apathy. Here is a man who finds himself in a crisis and instead of wallowing in self-pity, acts resourcefully. Imaginative shock issues an invitation which leads to decision and action."[5]

Brennan Manning says, "Men and women whose outlook on life is conditioned by the Dow are shrewder on the street than are the disciples on their spiritual journey. Unbelievers put us to shame. Imitate their shrewdness!"[3] We are being called to shrewd action. Do you have lots of ideas brewing around in your head? Are they on paper? Why not? Many times, a book of this nature will get the creative juices unplugged and flowing, but that's as far as it gets. In order to see through the vision and the ideas, we must have faith to act. The man in this parable was noteworthy because he got out of his head and took the necessary steps to make things happen. Jesus is calling us to be astute in stewardship of our "talents." I am referring here to another parable that Jesus told in Matthew 25:

"It's also like a man going off on an extended trip. He called his servants together and delegated responsibilities. To one he gave five thousand dollars, to another two thousand, to a third one thousand, depending on their abilities. Then he left. Right off, the first servant went to work and doubled his master's investment. The second did the same. But the man with the single thousand dug a hole and carefully buried his master's money. After a long absence, the master of those three servants came back and settled up with them. The one given five thousand dollars showed him how he had doubled his investment. His master commended him: 'Good work! You did your job well. From now on be my partner.' The servant with the two thousand showed how he also had doubled his master's investment. His master commended him: 'Good work! You did your job well. From now on be my partner.' The servant given one thousand said, 'Master, I know you have high standards and hate careless ways, that you demand the best and make no allowances for

error. I was afraid I might disappoint you, so I found a good hiding place and secured your money. Here it is, safe and sound down to the last cent.' The master was furious. 'That's a terrible way to live! It's criminal to live cautiously like that! If you knew I was after the best, why did you do less than the least? The least you could have done would have been to invest the sum with the bankers, where at least I would have gotten a little interest. Take the thousand and give it to the one who risked the most. And get rid of the "play-it-safe" who won't go out on a limb. Throw him out into utter darkness.'" (*The Message*)

If this isn't a call to deeper trust and action, I don't know what is. We think that our creativity is an extravagant excess that we might get to if there is time at the end of the day. Jesus would call this a terrible tragedy. We, like this servant, get hung up on disappointing others and go into hiding. We decide it's not worth the risk and start digging in preparation for the burial. We evaluate the gifts that have been given to us, and in our estimation find them wanting. So, we reject them in the name of perfectionism, fear of rejection, and disappointment. Our trust wanes and our holes deepen. Recall how the servant with $1,000 assumed his master didn't know what he was asking, and since his talents weren't the best, he did the safe thing and justified his inaction. He listened to voices saying he wasn't good enough and that his master was harsh, preferring caution to risk.

How do we challenge the voices that contradict our belonging? How do we choose something else? Henri Nouwen says, "The choice for my own sonship is not an easy one. The dark voices of my surrounding world try to persuade me that I am no good and that I can only become good by earning my goodness through 'making it' up the ladder of success. These voices lead me quickly to forget the voice that calls me 'my son, the Beloved,' reminding me of my being loved independently of any acclaim or accomplishment. These dark voices drown out that gentle, soft, light-giving voice that keeps calling me 'my favorite one'; they drag me to the periphery of my existence and make me doubt that there is a loving God waiting for me at the very center of my being."[6]

It is through crazy and wild trust that dark voices are rendered impotent; a trust that says, "I will forsake all other possibilities and trust in God's provision." Trusting in God is not blind. You know who you're trusting in. You are not jumping over the edge of a cliff with your eyes shut tight, just hoping that things will work out, and all the while thinking you should have buried those talents. You are jumping with your eyes wide open, looking full in the face of reality, knowing that He is coloring a much larger canvas than we can even imagine. This makes Him unsafe. Our suspicions creep in simply because He calls us to jump. We question His goodness even though it's really not a question of goodness. We do know Him to be good, but we also know Him to be wild and untamed. He goes into dangerous places and asks His servants to follow along. It is so hard to trust because He does not remove the element of danger.

We need to decide how much we will spend and invest. We must count the cost. "Don't cling to cheap, painted fragments of glass when the pearl of great price is being offered,"3 says Brennan Manning. Before we can venture to trust God, we must understand why He is worthy of our trust. Why would we free fall? Why would we trust in such a surrendered way? We must free fall into HIM. My friend Lauri reminded me that we are not trusting in God's provisions or attributes. We are trusting freely in *Him*, not what He gives. We know *Him*. He has revealed Himself to us; therefore, we know *Him*. We don't know of *Him*, we know *Him*. His essence, His person is what we trust because we have known *Him*. That is truly astonishing.

Trust My Supply

There is something about serendipitous moments. You know what I'm talking about: moments that come to pass after being fervently prayed over and thought about. Or moments that come to pass that had only previously been a fleeting thought. Deep longing colliding with reality; a place where you can see the hand of God scooping you up in His arms and expressing His deep care for you. Here's what I mean: You've been thinking about taking a watercolor class

What is
true
for any of these
seasons is that
God
supplies

and your friend just happens to invite you to join her. You recently composed some new songs and your friend who owns a music café is booking a line-up for songwriter's night. You have wanted to take guitar lessons but don't have an instrument. You run into someone who is scrapping their guitar. All it needs are strings and it's yours. These are road signs; affirmations that we are moving in the right direction. We move toward the sound of the Shepherd's voice and start to do "crazy" things as we follow Him into our callings. He affirms our movement by teaching us to trust His supply. Many times, as we move out in faith toward things that we never thought we could do, God gives us what we need when we need it. The tension comes as we seek Him. Sometimes the urge is to run away from Him and the callings of the day. Sometimes the urge is to run out in front of Him and orchestrate things on our own and force what we want. Sometimes, He says simply that we must wait. Other times, we must toil until our fingers are raw. What is true for any of these seasons is that God supplies. He causes blossoms to open. The moment we force the blooming process, the flower wilts. We do not have the power to make things flourish. That power belongs to God alone.

Ultimately, we have no control over the outcome of anything. We only have the power of the present moment and the present reality. When we follow, He supplies. When we don't follow, He comes and asks us again. Sometimes we are reluctant. He still invites. This became readily apparent one time when I was preparing for a retreat on creative awakening. Ten days before the event, my dear friend Andi, who graciously offered to host the retreat and prepare two meals, was laid flat out on her back. She could not move for three days. The retreat hovered in midair. Six days before the retreat, her father passed away. She was going to California to bury him, probably that weekend. The retreat had left midair and had fallen into the depths. There were also intense circumstances surrounding the retreatants, and I wasn't even sure half of them would show up anyway. The retreat team had never served on this type of retreat before. I prayed. I sought counsel. I prayed. As I sat in the silence, I heard God say, "Wait to hear from Me."

I waited five days. I toiled. I came close to calling off the retreat at least 50 times. One day, I looked out the window as if to say, *What will be your answer today, God?* Up to the porch fluttered a hummingbird. He came up to the window, hovered for a moment and flew away. I'd never seen a hummingbird in my yard until that day. At first I was incredulous that God would speak to me that way… it seemed so strange. Yet, He did speak to me that day. I had been toiling all week, trying to fill in the holes. Andi is the most hospitable, generous person I know, and her absence left a huge hole. It also left a hole because I knew she was somewhere dealing with the grief and unfamiliarity of burying a father. I felt divided. But what the hummingbird said to me in that brief moment was that my days of labor had purpose. My toil was ordained. The outcome was not clear but my calling was. I was to proceed with my work and trust His supply. Many times I wanted to run out in front of him and bring order to something that seemed chaotic or too open-ended. I wanted to trade the ambiguity for concrete control. The hummingbird reminded me that I must follow Him and not try to illuminate things that are not ready to come to light. The retreat did happen. Andi was in California and we missed her. But what God desired for that day came to pass and it was glorious. Sometimes we must wait, and in the waiting, we must labor, only to have delayed fruit. But the fruit will come and it is a lesson in trusting His supply. Living in trust is necessary while living among the question marks that ambiguity brings. Just as art is full of mystery and open-endedness, so is life. Closure is not the ultimate prize. Living life without answers brings us into a deep, abiding trust in One who has deep desires for us and our lives. If we are able to experience life without answers and to trust that we don't need them today, we have experienced surrender in its purest form.

We must differentiate between our belovedness and our giftedness. God does not extend His love to me to the degree that I am useful. I am beloved in Jesus because I belong to Him. Period. He did not find favor with me because of my résumé, my abilities or anything that I can give back to Him. He just loves me because He chooses to and He is a fierce lover. I think my favorite passage in scripture would be Song of Songs 8:6-7, – "Set me as a seal upon your heart, as

a seal upon your arm, for love is strong as death, jealousy is fierce as the grave. Its flashes are flashes of fire, the very flame of the Lord. Many waters cannot quench love, neither can floods drown it. If a man offered for love all the wealth of his house, he would be utterly despised." This is about God's love, not about its object. We make much about the object of His love and evaluate whether the object is really worthy of this fierce love. That's what makes His love so incredibly intoxicating. He just is this way; what we bring to the table doesn't change who He is. When we bury the talents, it saddens Him because in doing so, we have made it about us and diminished who He is. If we were aware of how fiercely He loves us, those talents would be showing up in our investments of life! When we become familiar with this crazy, maddening love, we operate out of it. All that we are flows from love that sent One so passionately in love to His death. When what we do is fueled by the knowledge of our belovedness, we can find freedom from people-pleasing and fear of rejection. We have another kind of knowledge, which says, "Celebrate, for I have made you this way. When you share your gifts, I delight in your process and I call you beloved." You are beloved before you are gifted.

As Richard Rohr says, sometimes our cross, specifically as artists, seems inglorious, mundane and ever present. If it feels this way, chances are, you are on the right track. The all-or-nothing mentality can really stunt our artistic growth. Our movements are more measured. If you take a small step almost daily, you're making great strides toward your goals. Artistry really doesn't consist of large, long steps, but short and small ones. Treat yourself with godly mercy and grace.

So, what is at the root of our laziness, procrastination, apathy, inaction? I believe it is fear. When we look deeper, we can usually recognize that these surface deficiencies are the result of something going on within our core person. We know as artists and followers of Jesus that we cannot overcome these deficiencies by striking them with a mallet. Our fears are like that arcade game, Whac-A-Mole, where another mole pops up its head for every head you clobber. We must get to the bottom of our fear. Today is the day we make a choice to walk through the fear and make a small step toward our creative goals. As we walk further into

what it means for us to be creative image bearers of God, the pull to abandon ship becomes stronger. We lose the sure footing we had when we stayed in our hiding place. There is a comfort in staying still, but only for so long. If we are ever to arrive at the next safe place of rest, we must put one foot in front of the other. What step will you take today?

The Inescapable Beauty of Jesus

Does it ever feel better to be an orphan rather than to belong to a family? It does to me. Sometimes, I just want an escape; not from pain, not from life, but from the wounds of love and beauty. Pain and life, I can handle all by myself (wink, wink). But the fierce love of Jesus—the beauty, the light, the truth, the goodness—these are wounds. His extravagant love cuts deeply into joints and marrow. It brings an ache. I don't have the capacity to understand His stunning brilliance in this world and in my heart. It stays mysterious. Jesus wounds us because the way that beauty hits us. The gospel wounds us. We can either set out to destroy it, or it can destroy us. It destroys us and reconstructs us again. It is very much like the picture of Eustace, the dragon in chapter four. We must submit to the wounds that He brings because He is making us beautiful. Then, we become participants of true beauty, since He who is beautiful is establishing it in our hearts. We become the loveliness of Jesus. In light of this, we must not exploit this unsearchable gift by self-disparaging thoughts and words. By doing so, we insult the beauty that Jesus is crafting within us. Let's resist our urge to run away from the pool; and let Aslan peel away our scales and heal our wounds.

Jealousy

Jealousy and envy are byproducts of the thought that we aren't good enough. We become discontent and long for other gifts. We may even despise the talents God entrusted to us. We look around us and engage in the comparison game. "I wish I were as pretty as she is." "Why don't I have the audacity that she has?" The elder brother starts to play out in our relationships and we find ourselves picking up fragmented pieces of damaged relationships. Like the elder

brother, we're angry over the good of another. Stuck in envious self absorption, we can't desire good for others. Again, like any other powerful emotion, jealousy is a map. You can follow it to find, at the core, your fears.

My jealousy looks like suspicion, anger, disdain, rejection, indifference and fear. The language in the Bible about God's jealousy is so compelling. His love is fierce. I can sense His jealousy in things He has made like fire, the ocean, fierce storms, and certain animals. God's jealousy draws Him to release us, know us, accept us, and conquer death. His jealousy says, *I will fight for you. I will draw you in closer and be beautiful to you, so you will scorn your other lovers. I am so jealous that I will draw you in despite your resistance and make known my heart to you, because that is who I am. You think your choices are the sum of my story. Your choices are secondary to my story. My story is that I am going to be with you. I have made a way. All other choices either lead you to my presence or away from my presence. But, you are always in my presence because of my choice to always be in yours. This transcends all your choices!* God's jealousy underscores His love.

Pulls/Blockages

Our creativity is a profoundly spiritual issue. If we are avoiding spiritual intimacy, we are starving the artist. The hunger it creates in our spirit comes out sideways. We try to satiate our hunger with things that do not satisfy. There are things that pull at us, that we are drawn to. When you feel a "pull" toward a certain thing, can you ask yourself if this pulls you toward God or away from Him? Does it pull you toward more love and life, or away from these things? One of my pulls is food. For a long time, I didn't even know I was buying into a counterfeit lover. After my third child was born, it sort of slapped me in the face. I came to a realization that I was sixty pounds overweight. Through circumstances swirling around, I became aware of what food was for me. It was comfort, relief from loneliness and isolation, an escape from intimacy. Food never required anything of me; it understood my deep emotions and allowed me to pour myself out without the risk of pain, sorrow, rejection or abandonment. It was an acceptable form of escape. I poured myself emotionally into food

while keeping distant in relationships. It wasn't until I started pouring myself onto written pages before Jesus that I experienced some freedom. It was in the pages of my journal that I came to realize how emotionally attached I was. Through a very difficult and painful journey with Jesus, I was able to identify the triggers that led me to food.

We all have our favorite things that pull us away. Anytime I felt a pull to the refrigerator I asked myself, "Is this moving me toward God or away from Him?" When I could honestly answer that it was a pull away, I would move in the direction of something else that would pull me toward God. It didn't even have to be something "spiritual." Reading or journaling became a way for me to hook myself back into God's love and acceptance. Or sometimes it was prayer, or exercise. Making the cognitive and emotional shift away from numbing myself and toward some goodness that would lead me back toward God and his kindness and love during this time created healthier ways of responding to what was real in my life. You can probably identify a few of your favorites, as well as the triggers that lead you there. If not, it is really important in this stage of your awakening to identify them. Be careful with your newfound creative freedom. Our creativity is meant to lead us into gratitude and intimacy. Oftentimes, with hearts that are prone to wander, art can become another addiction or escape. Have you entered into His courts with the eagerness of a child? Those pulls will start to be pretty impotent in comparison with the rich banquet table to which you have been invited! The King has dressed you with the most extravagant, exquisite wedding garments and He has prepared a feast in your honor. You keep pacing back and forth at the door, peeking in and then walking by, not quite sure how to enter the room. What is keeping you from actually walking through the door? You walk away alone and head to the drive-thru at McDonald's! Isn't that what it's like to choose quick relief from pain? Not today. Come and "delight yourself in the richest of fare" is what Jesus says in Isaiah 55. It's a daily choice. It is a daily choice toward long-term health. That false comfort may work today, but will sabotage your health and creativity in the long run. The things we love more than Jesus offer relief for a little while, but they will always fail us later,

thanks to the mercy of Jesus. Don't let the longing for a quick fix be the propeller for your choices today. When we choose out of love rather than fear, we become deeply connected people. We are intimate with ourselves, each other, and God.

Fasting

During the course of writing this text, I fasted for three days. The first day was terrible because I had a caffeine headache that progressed to throbbing pain by the end of the day. I slept a lot the first day. The second day, I was overwhelmed with my work. The third day, I was tired, hungry and really crabby! In order to hear from the Lord and get some work done, it was necessary for me to go into the wilderness for a time, suffer and fight, and remove the vices that are normally available to bring much comfort and distraction to my heart. The vices that I left behind those three days were food, caffeine and computer time. I want you to focus on one particular pull—the one that screams out at you as you go through this week's reading. Feel no shame!! We all have them. They may have even had an innocent beginning. Name one. Observe it. Look at it from all angles. What need is it serving? How does it eclipse your sight of Jesus? Where we have clutched something tightly, we have great fear. Where there is fear, there is a deep, deep longing. What is that fear? What is the longing? How is it that Jesus isn't tied to this longing? Ask Him in. Ask Him to show you about this longing. Ask Him. Listen to Him. Write down all that you hear as He speaks to you. Understand the rebuilding that takes place is beautiful! The way that God brings about redemption is really quite extraordinary. His redemption in our lives mimics the grand story He is telling, only He works His redemption in smaller facets of smaller narratives. He created us. We walked out of the Garden. Now, He is restoring us by tearing down the fabricated houses we have built to hide ourselves in. He has begun a renovation process that will reveal a far greater and grander house than the original! In this way, the answer is far greater and glorious than the question ever was!

QUESTIONS FOR REFLECTION

Day 1: Choose one of the nine motivators listed at the beginning of this chapter that most describes you. Write it down in your journal. Ask the Lord some questions about your motivations. What is the antithetical fear of that motivation? (For instance, if you identify with #1, your fear may be that you would have to admit wrongdoing or fear shame and embarrassment from seeking forgiveness).

Day 2: In light of what you are motivated by, what is it that you want? What will happen if you do not get it? What will happen if you do get it? Do you already have it?

Day 3: God has wired you with the particular motivations in your heart. These are not to be condemned. In what ways have you seen Him make these motivations in you beautiful?

Day 4: Read the parable of the talents again. How does this parable connect for us the importance of creative awakening? What is one thing you can hear in the dreams that Jesus has for you?

Day 5: What idol has your heart today? Why? How can Jesus fill up that hollow place instead?

Day 6: Where in your life have you experienced open-endedness and
 question marks? How has it been valuable to delay conclusion?

Day 7: Name someone of whom you are jealous. (Focus in on one person.)
 Why do you feel this emotion toward this person? What does he or
 she have that you want? What can you learn from this person?

SOLITARY PERUSINGS

"My beloved speaks and says to me, 'Arise, my love, my beautiful one, and come
away.'" (Song of Songs 2:10)

Identify one thing that tends to pull you away from God. Choose something
that serves as a distraction for you artistically. Plan a day that you can remove
it altogether. Make it a day that you can replace the idol for time with Jesus.
Whatever thing you choose will be a ravenous beast and won't give up without a
fight. Carve out some blocks of time during this day; maybe two or three hours
in the morning, two or three hours in the evening. Make sure this time will be
free of interruptions and noise (i.e. books, TV, etc). Bring your journal and
your Bible. Do something for your aesthetic sensibilities (light a candle, bring a
cup of tea). Part of the challenge here is our fear of silence. We spend so much
time drowning it out. If we are quiet, we might have to look ourselves square
in the face and see our poverty. When this happens, rest assured that Jesus has
embraced every part of you! He has embraced your poverty. In order to follow
Jesus, you must do this also. We must learn to love what is hardest for us to love:
the darker parts within ourselves were embraced and swallowed up by Jesus.
Silence in the presence of Jesus will allow us to view that which we know very
well how to hide. In the presence of Jesus, we will come to terms with what He

has embraced and will embrace it ourselves. Only then will the beauty of Jesus break in and be lovely and breathtaking. Ask Jesus these questions:

How have I used this pull in my life to avoid my own poverty?
Now that I have looked into my poverty, what do we do with it, Jesus?
How have You swallowed up my poverty?

Secondly this week, take your table from week three and embellish it. You could decoupage it or make a tablecloth. Do a mosaic. Paint it, stain it, stencil it. Make it beautiful.

WAKING UP *grey*

The provisions of the table are overwhelmingly lavish today. New tastes, textures, sounds and aromas are all about. The sky is full of brilliant color as the sun sets over the mountains. The table rests in a meadow of gold, dotted with bright red, purple and yellow wildflowers. The air is fragrant with their sweet scent. The chatter of wildlife fills the air with celebration. She drinks deeply with all her senses; it brings peace. Her Lover invites her into the meadow to run, skip and dance. She comes in her bare feet. She doesn't remember laughing so hard in a long time. She understands in this moment how the pearl of great price brings laughter, sometimes through tears, between her and her Lover. Their laughter continues on for quite some time; sounds of singing and laughing echo across the meadow and up the hills toward eternity.

seven

FAITH: RECOVERING PURPOSE

"Arise and eat, for the journey is too great for you."
(1 Kings 19:7)

Israel's leader, King Ahab, did not have a heart like David. He and his wife, Queen Jezebel, led the people of Israel to worship other gods. The king and queen set up altars and sought to kill all the prophets in the land. And they almost succeeded. The only surviving prophet was Elijah, who fled to preserve his life. God met Elijah in hiding and cared for him. When the time was right, Elijah returned to Israel and challenged the gods. When Jehovah God won the challenge, the prophets of Baal were executed. News of this slaughter reached Jezebel's ears. Read this passage: "Ahab told Jezebel all that Elijah had done, and how he had killed all the prophets with the sword. Then Jezebel sent a messenger to Elijah, saying, 'So may the gods do to me and more also, if I do not make your life as the life of one of them by this time tomorrow.' Then he was afraid, and he arose and ran for his life and came to Beersheba, which belongs to Judah,

and left his servant there. But he himself went a day's journey into the wilderness and came and sat down under a broom tree. And he asked that he might die, saying, 'It is enough; now, O Lord, take away my life, for I am no better than my fathers.' And he lay down and slept under a broom tree. And behold, an angel touched him and said to him, 'Arise and eat.' And he looked, and behold, there was at his head a cake baked on hot stones and a jar of water. And he ate and drank and lay down again. And the angel of the Lord came again a second time and touched him and said, 'Arise and eat, for the journey is too great for you.' And he arose and ate and drank, and went in the strength of that food forty days and forty nights to Horeb, the mount of God." (I Kings 19:1-8)

Have you ever been in so much pain that you wanted to die? A mighty prophet of God, yet a weak man, Elijah pleaded for death before the Lord! Imagine his story. People he loved and respected were put to death because of their love and devotion to God. His prophetic words sent him running for his life. Earlier in the story, Elijah's drought prediction for the land of Israel got him into trouble with the king. He fled that time, too, and God sent ravens to sustain him with bread and meat. Elijah spent long seasons in the wilderness and in exile. When he did return, he did so to challenge the king in obedience to God, only to have the queen seek his life. When Elijah returned to the wilderness yet again, he must have taken inventory of his desperate life. He was inexorably alone—no home or family, no one to speak sanity to his heart. He had enemies on every side; enemies with great power. His faith waned. He lamented that he was no better than his fathers. There was utter despair in those words. He must have felt like a coward fleeing into the wilderness. Do you recognize the self-loathing as Elijah compared himself to his ancestors? He had given up… lost hope. His vision and purpose were lost in the isolation of fear and darkness. There, in the wilderness, he came to the end of himself. He fell asleep.

When Elijah awoke, God blessed him with the knowledge that he wasn't alone. He awoke to the touch of an angel of the Lord, who said, "Arise and eat." The solitude underscored Elijah's need for God's provision of nourishment and companionship. God's invitation to us is the same: arise and eat. *Arise*: have faith

to believe that the Lord God calls. Have faith to answer loudly! *Eat*: come and feast at the Lord's table. He will provide for your need at the appointed time—a cake baked on hot stones and a jar of water—or an extravagant feast.

A second time, Elijah fell asleep and was awakened by a touch. "Arise and eat, for the journey is too great for you." The journey is also too great for us! The long, arduous journey is the backdrop for words like faith, hope and love. If the journey were a leisurely stroll, we wouldn't have these words in our vocabulary. We wouldn't need faith to believe we can prevail. We wouldn't need hope that the journey takes us to a heavenly destination. For the times in the wilderness when we have lost the strength to take the next step, we must be porous enough that we can receive the next provision, the next gift. We must arise and eat. We must approach the Lord's table and receive nourishment, companionship, healing, and rest. We must bring to Him the words of Jezebel, the voices warring against our souls, and let His words drown them out. The truth we find in the wilderness is that the isolation is too great for us. But in that truth we are set free from trying to make the journey manageable. Like God Himself, the journey is out of our control. It's only in the wilderness that we find the freedom to release our white-knuckled grip of the self-drawn map that guides our steps. This is true faith—that we arise and eat with dignity. True faith says that we know what God says to be true, despite things in the world and in myself that would assault the truth. I will jump off the cliff because I have seen and tasted that the Lord is good.

What would compel us to jump off a cliff and take meaningful steps that seem to be so scary? Why indeed, when the vastness of the Grand Canyon lurks below? It is a risk worth taking. Think about the exhilaration of transforming beauty. Do those old voices come in and try to rob your joy with feelings of guilt? Consider Frederick Buechner's response to feeling guilty for receiving goodness from the hand of God: "Warmth. Light. Peace. Stillness. Love. It seemed to me that wherever these things are found in the world, they should not be a cause for guilt but treasured, nurtured, sheltered from the darkness that threatens them… they are like oases in the desert where green things can grow and there is refreshment and rest surrounded by the sandy waste; how in a way they are like

the monasteries of the Dark Ages where truth, wisdom, charity were kept alive surrounded by barbarity and misrule."[1]

Entering the Battle

Commitment to the creative process is a battle. It simply will not happen without conflict. Any heart change and art change will be fought over. Transformation requires deep prayer and suffering. Sometimes, we will come to the well bloodied and bruised. But we still come because we know the battle is won. Do you have fellow sojourners who know the hardship of battle? I love the scene in *The Lord of the Rings: The Two Towers* when Sam and Frodo, the main Hobbit characters, are seemingly at the end with no hope of returning home. Sam says, "It's all wrong. By rights we shouldn't even be here. But we are. It's like in the great stories; the ones that really mattered. Full of darkness and danger they were. Sometimes you didn't want to know the end, because how could the end be happy? How could the world go back to the way it was when so much bad happened? But in the end, it's only a passing thing; this shadow. Even darkness must pass. A new day will come. And when the sun shines, it will shine out the clearer. Those are the stories that stayed with you, that meant something even if you were too small to understand why. I think I understand; I know now. The folk in those stories had lots of chances of turning back, only they didn't. They kept going because they were holding on to something." "What are we holding onto, Sam?" asked Frodo. Sam answered, "That there's some good in this world and it's worth fighting for." Half the battle is showing up. To show up, we must believe that the beauty produced in this world matters. Wherever beauty emerges, there will be a protest and some kind of opposition.

The following passage tells us how Jesus asks that we show up for our creative and spiritual process: Revelation 3:14-22 says, "And to the angel of the church in Laodicea write: 'The words of the Amen, the faithful and true witness, the beginning of God's creation. I know your works: you are neither cold nor hot. Would that you were either cold or hot! So, because you are lukewarm, and neither hot nor cold, I will spit you out of my mouth. For you say, I am rich, I

have prospered, and I need nothing, not realizing that you are wretched, pitiable, poor, blind, and naked. I counsel you to buy from me gold refined by fire, so that you may be rich, and white garments so that you may clothe yourself and the shame of your nakedness may not be seen, and salve to anoint your eyes, so that you may see. Those whom I love, I reprove and discipline, so be zealous and repent. Behold, I stand at the door and knock. If anyone hears my voice and opens the door, I will come in to him and eat with him, and he with me. The one who conquers, I will grant him to sit with me on my throne, as I also conquered and sat down with my Father on his throne. He who has an ear, let him hear what the Spirit says to the churches.'"

Let's focus on the three things Jesus counsels us to buy from Him so we are battle-ready. Just like faith, hope and love in 1 Corinthians 13, the three things God counsels us to buy are things only God can offer. The Laodicean church was fat and sassy, proud and complacent. They considered themselves rich, lacking nothing. "We've got everything we need right here, thanks." Isn't that what our culture preaches to us? Autonomy, self-sufficiency, and the absence of neediness? The "we've got-it-all-together" mentality?

The items Jesus counsels us to buy are gifts He has already purchased for us. He tells us to purchase these gifts so that a transaction takes place... so that we will claim ownership. Jesus has made us rich, clothed our shame, and given us sight. The paradox is that to be poor is to be rich, and to be rich is to be poor. Jesus says in Rev. 2:9, "I know your tribulation and your poverty (but you are rich)." He was talking to future martyrs. He warned them not to fear for the deep suffering they would soon experience. Of course Jesus would turn our ideas of rich and poor upside down! It was no accident that Jesus came to the world in a posture of poverty, in a lowly manger. He came to abolish our faulty God-assumptions. The notion that we may not approach God until some sense of worthiness or cleanliness is met to our liking is absolutely obliterated by the manger. He spliced our distance from God by becoming our servant.

Suffering yields gold from the refiner's fire when our faith is tested in it. To buy refined gold means to suffer in the light. Victor Hugo's lines again ring true,

what do you
TREASURE?
what does your
HEART SEEK?

"There is suffering in the light; an excess burns. Flame is hostile to the wing. To burn and yet to fly, this is the miracle of genius."[2] Though we suffer, we will not be destroyed. "When you walk through fire you shall not be burned, and the flame shall not consume you." (Isaiah 43:2b).

This is true because Jesus was crushed in our stead. *He says, Buy gold from Me—I have what you need. The only place to find gold—pure gold—is in my hands.* His riches, His gold, are a different kind of treasure. What do you treasure? What does your heart seek? What is valuable to you? You can know what you value by knowing your heart. "Where your treasure is, there your heart will be also." (Matthew 6:21) As we learn how to suffer well, our hearts begin to treasure the things of God and we begin to rely on Him to fulfill our deepest longings.

Faith is:

- Our response to who Jesus is; not what He does
- Clinging to Jesus regardless of swirling circumstances
- Understanding that He holds all things together, even precarious life events
- Working out the truth that God is good amidst seemingly contradictory evidence of such
- A confident remembering that we have been met by God
- The realization that you will be in difficult places with difficult people—always – because that is where Jesus is.

Surrender to the refiner's fire, whatever that may look like for you. Surrender only comes with deep trust. Control and trust simply cannot reside together. You either trust God or you expend energy trying to control your environment and relationships out of suspicion that God is not for you, not trustworthy, not powerful enough.

We follow Jesus into suffering. "Truly, truly, I say to you, unless a grain of wheat falls into the earth and dies, it remains alone; but if it dies, it bears much fruit. Whoever loves his life loses it, and whoever hates his life will keep

it for eternal life. If anyone serves me, he must follow me; and where I am, there will my servant be also. If anyone serves me, the Father will honor him." (John 12:24-26). Herein lies the mystery that we experience: death brings much fruit. Death brings resurrection. When I release myself into the pain of appropriately letting something go, that is the very place where new life emerges. I have experienced this mystery in my life over and over. Jesus says if we regard our way of life too highly, we will lose it anyway. If we submit to the peeling away of a deadly way of living, we will bear much fruit. We will keep our lives eternally. Much of our lives as disciples of Jesus is spelled out right here in these words: "If anyone serves Me, he must follow Me." Jesus walked the narrow road of death. We follow Him on that road and for every death we experience, we also have a resurrection that bears much fruit. I'm reminded of my trip to Peru a few years ago. In the small, remote village where we were serving, there was death everywhere. It was as thick as the dusty, dry air that hadn't been cleansed with rain in months. Everything was brown. They get virtually no rain. It's dirty and dingy and smelly. There's nothing green for miles. It is desolate; nothing grows or flourishes in this region. It's a challenging place for the human heart, too. I was standing outside the little church thinking those thoughts in my mind with a helpless ache for all the human hearts that inhabited that part of the earth on a daily basis, waiting to catch the bus back to town. It was then that I looked over at the wall next to me and noticed this huge bush full of geranium blooms. It was almost waist high and the colors on it were brilliant; beautiful green foliage and large reddish-pink blooms. I was incredulous as I blinked at it, thinking how misplaced it was. How in the world could this huge, beautiful, flourishing parcel of life be growing in the midst of this dusty and cruel, environment? Is it fake? I reached down and felt it and it was as real as the poverty and hopelessness that crept into my bones from the air around me. Jesus softly spoke to me words that He could only speak. *Resurrection is real. I am He who can breathe life out of nothing. I am He who will bring life from the deaths that you die.* This is the hope of God. Jesus is a living, breathing example.

Reading through the Old Testament, something becomes abundantly clear… virtually, all of the Bible and all of our history as humans have been written outside of the Garden. God's heart is a heart of long-suffering abundance. We have simply lost our memories of the Garden. We have lost our memory of God's abundance. We forget that everything belongs to God and He is generous in the way He wants to give.

There are three ways we can respond to the fire:

1. Spend our lives avoiding fire—like the church of Laodicea. We have everything we need… we've shored up all our vulnerable spots so that we are not weak and we do not suffer. We respond stoically to life. We trade in all our relationships, all of our deep knowing for upper-level courtesy. We become non-porous surfaces. Nothing can slip through the cracks down into our hearts. In this way "we say we have everything" because we have shored up our hearts from breaking.

2. We are destroyed by the fire. Have you ever seen a person destroyed by the wind and weather of life? A dead soul shelled in a disintegrated body? Someone who has given up? Her body may not be dead, but her soul and spirit are. The fire of life has consumed her.

 If you find yourself in the narrative of these first two responses, please take heart! When we acknowledge our familiarity with these places, we allow something new to take up space. Disillusionment can be an entry point for deeper, more authentic relationships to form. Coming to the realization that vulnerability feels repulsive becomes a gateway toward a more cruciform life, thus taking taking greater creative and relational risks.

3. We come forth as gold! We find new passion and a sense of purpose in our work. We enter into the suffering of the flames and are not consumed, but refined. We know how the story ends, so we fight the battle because we know there is something worth fighting for! "But He knows the way that I take; when He has tried me, I shall

come out as gold." (Job 23:10) We will be tested. We will suffer because we love. It is our cup as followers of Jesus. We share in the fellowship of His sufferings. Jesus said, as He was being arrested (when Peter drew his sword), "Shall I not drink the cup that the Father has given me?" (John 18:11) Sometimes our cup is bitter, but do not be afraid! We will not be consumed. John Piper says, "The furnace of affliction in the family of God is always for refinement, never for destruction." But, there is no painless path to glory. "It is no more possible to become pure painlessly than it is to be burned painlessly." (John Piper) But our promise of refinement is this: "Blessed are the pure in heart, for they shall see God." (Matthew 5:8)

We hold the tension of life and death within our hands... when we buy refined gold from Jesus, we push back the effects of the Fall and hold the curtain back to the display of God's beauty in His world. There is no place that God has not been. There is no place that God does not inhabit. He even inhabits the deep—the deepest, darkest places on earth, under the earth, above the earth. He inhabits your darkness.

I have been aware recently that there is a dichotomy to everything I encounter in life. This dichotomy is found everywhere from my garden to my child to life events to relationships. It is the dichotomy of good and evil. This is the tension that we bear. My garden, for example, is full of beautiful wild-flowers. It also has weeds and leaf-eating insects. It needs care and pruning. We, meaning humanity, have an ability apart from other created beings to reflect God's image. We are also fallen creatures who inhabit a fallen world. Because of these realities, we have the capacity for great good and great evil. Any life event, from small to great, has both good and evil mingled. I long for the day when things are untainted and intrinsically good. When we make the decision to fight for good, we move ever-increasingly toward that day. We grieve over the evil that we carry with us and celebrate over the good, the true and the beautiful. Holding this tension really matters.

Stories That Really Matter

What makes a story great? Good defeating evil… we're in a fight; we have a part to play in the narrative. But, ultimately, it is out of our hands. There's only one person who can defeat evil… and it required His death. But, in His death, we have found life. He is master of death. He holds the keys of death and hell. The mystery of strength and weakness, resurrection in death, sorrow which leads to joy—we hold the tension of life and death in our bodies; and in our souls, in our minds if we choose to follow the great commandment to "Love the Lord your God with all your heart, soul, mind and strength." (Mark 12:30) If we make a conscious choice to do that today, we choose to hold the tension of life and death in our hearts, souls, minds and physical bodies. To love is to suffer. To love is a dying to self; a releasing of our strongly-gripped identities. We release whatever identity we've constructed and viewed with such value into the hiding place God has created for us in Him. We're there with Jesus. We are free from what we've said we need to be and are free to be what He says we are. Our old identity dies with a flicker and a smolder…

As we fight to love God with our identity, sometimes that old man, the false person, will waft up from the smoldering ashes and threaten to come alive again. That is the tension we hold of life and death, the fight of light and dark. It has to do with what we believe, what we feel, what we long for, what we run to. When we are content to be dead to the old and alive to the new, we are in a place of wisdom, held within the bosom of our Beloved. We're not trying to run away from home and find a hiding place for ourselves. We are at home, feeling His pleasure over His family. We are in touch with our humanity. It is good to be human! Richard Rohr writes, "When civilization has flourished, when great music, art and literature have emerged, it's always when human beings have felt good about being human. That's exactly what faith gives us, a kind of extraordinary dignity. It gives us a sense of our own meaning: religion calls us 'sons and daughters of God.' If we can do nothing else, we can give that back to the world: that we are created in the image of God, we have come forth from God and we will return to God. We reflect part of the mystery of God."[3]

This is God's story: Creation, Fall, Redemption, Consummation. There are little vignettes everywhere with this story line. God's heart toward us is not punitive; rather, He tears down and rebuilds and inhabits! Solomon's Temple in the Old Testament is a beautiful metaphor for us. It was magnificently built, a stunning dwelling place of God! Then it was torn down and pillaged! But He rebuilt it and inhabited it during the whole process. You are the temple of the Holy Spirit! Refiner's fire means that the temple will be torn down and rebuilt, all the while offering a dwelling place for our God!! What a mystery! Inhabiting me even as consummation is yet to come! God says, *I live here with you. Make room for Me in my house!*

QUESTIONS FOR REFLECTION

1. "Arise and eat; for the journey is too great for you." What will it take for you to get up? What will it take for you to eat?

2. Are you in the wilderness? How has God met your need for nourishment and companionship?

3. How does it require faith to see yourself as God sees you?

4. Think back to a recent creative setback. What will it take for you to fight through it and continue to walk this road?

5. All biographies have tragedies and endurance written into them. These are the very places faith grows. Write about one tragedy in your life and the endurance that came with it.

6. Identify a time in your story when you were very aware that the fight was worth the cost. Did God meet you there? What prompted you to enter the battle? How can you infuse your current need with the awareness you had at that moment in time?

7. What are some small steps you can take to move toward your creative goals? Write a list. Set time limits in small increments.

SOLITARY PERUSINGS

There is a lot of imagery in this chapter having to do with fire. Spend some time pondering this passage from *Les Miserables* by Victor Hugo: "There is suffering in the light; an excess burns. Flame is hostile to the wing. To burn and yet to fly, this is the miracle of genius." Waking up the Grey presupposes that you have been burned before and the burning has caused you to slumber. To fly forward is to walk in the light and trust that the fire will not consume you. You will still fly! As you begin to work out what this means for you—how fire will work its refining magic as you dream of soaring (which is God's dream for you)—put it in your art. Maybe you will try a new medium. Maybe you will apply what you know to this project. However you do it, put it into a tangible form of art; i.e. a photograph, painting, drawing, writing, song, sculpture, drama, etc. Express

to Him what He is telling you and allow this process to be a prayer, a dialogue between the two of you. He has something He wants you to know; ask Him what it is and look for it to show up in your artistic expression.

WAKING UP *grey*

Grey found herself falling into the depths of colorless and formless vapor. Her soul ached, even amidst great freedom and newfound life. The grey lingered and lurked behind and before. Today it brought with it an ache of the soul. If she could shake it off and lay it down, everything would be fine. So she shrugged it off and found solace in a fully-packed schedule. There was no time to ache. She had a mound of laundry waiting, lunches to pack, small people to usher to and from school, work piling up. "I must keep moving," she thought to herself. But as the day went on, the cloud thickened and hovered above her.

In her solitude with Jesus that afternoon, she found the ache to be acute. It was the ache for color; the ache to be known. It was an ache for the Garden of old, where there was fullness and fulfillment. Nothing on earth could soothe, for she ached for another place. She realized in that moment that she must reside in the world with this ache. "I must! I can't lose the ache this side of heaven... I WON'T lose the ache. To lose the ache is to lose the dream of living in fullness. The ache is what calls me to the higher road. To ache is to fervently hope. I will not kill the ache."

eight

HOPE: OUR LONGINGS PURIFIED

"…their hearts, wounded with sweet words, overflowed, and their joy was like swords, and they passed in thought out to regions where pain and delight flow together and tears are the very wine of blessedness."
J.R.R. Tolkien, *The Return of the King*[1a]

When I need a dose of hope, I usually turn to the Old Testament. There I find people who are so much like me. The Old Testament reveals the Law of God and the inability of humanity to meet its requirements. Hope, you say? This is a hopeful revelation? Yes! This problem—all that is wrong about humanity—gives us an opportunity to see and experience the amazing kindness of the Creator. Strung all throughout the Old Testament, we see God's commitment to bringing His people back into sweet fellowship with Himself. This is what He is committed to because it is what He desires: sweet communion with His loved ones. What this requires— sweet communion—is no small sacrifice. It requires suffering; the suffering of

what does it feel like
WHEN A LONGING
HAS BEEN FULFILLED?

God and the suffering of His people. I find great hope in this. Yes, it requires suffering, but like Tolkien's brilliant words, the suffering we endure brings a joy we could never come close to without it. It is only through a mystical understanding of the supernatural work of the Holy Spirit when one can say "tears are the very wine of blessedness."

Freedom or Imprisonment?

Speaking of the Old Testament, we are much like the Israelites. There's safety in returning to Egypt. We understand what it is to be confined. We are consoled somehow when things are out of our reach. It gets us off the hook of doing the hard work. It justifies our secret desire to return to bondage. Somehow, we start to believe God finds pleasure in putting our dreams within our sight, but just beyond our reach. We begin, like the Israelites, to be suspicious of God and complain for relief from freedom.

Where do our longings come from? What does He long for on our behalf? Does He change what we long for? Do our hopes ever come to fruition? Must our hope always be deferred? These are questions we need to ask. When we long for things God has made us to long for yet without fulfillment, we long for lesser things: "Indeed, if we consider the unblushing promises of reward and the staggering nature of the rewards promised in the Gospels, it would seem that our Lord finds our desires not too strong, but too weak. We are half-hearted creatures fooling about with drink and sex and ambition when infinite joy is offered us, like an ignorant child who wants to go on making mud pies in a slum because he cannot imagine what is meant by the offer of a holiday at the sea. We are far too easily pleased." (C.S. Lewis, *The Weight of Glory*). Have you whittled away at your dreams and longings? Did they seem too big and overwhelming that you gave up and decided to reach for something easier or quicker? One way that we walk back into captivity is to make our dreams be risk-free. Risk-free dreams are also void of passion. PASSION. What moves you? Do you know? Have you forgotten? Could you ask God to bring you back in touch with what you are passionate about?

What does it feel like when a longing has been fulfilled? After much toil and hard work, to see the object of your hope realized? Can you recall a time when you experienced longing come to fruition? Did you celebrate? Do you remember what it felt like? In the movie, *Pursuit of Happyness*, we see the pursuit of a dream in all its reality. We like to romanticize God and our dreams. We think that if we just walk through the right doors and double up our prayer time that He will honor our efforts and give us what we want. But our longings don't come easy. In this movie, Chris (played by Will Smith) was thwarted in his attempts to achieve his dreams. In the end, it took much pain, sorrow, toil, and sacrifice. Because of this reality that we must toil for our longings, we tend to shortchange ourselves and settle for smaller things. There comes a time in our work that the play is over and it feels much more like work than play. This is where things get difficult. This is the place where we are ready to exchange our passions for something with a little less fire. When you get to this place, you must press through the discomfort. You must show up for work. Resist that voice that would convince you to keep playing with the mud pies because you are afraid of the unknown. **Your dreams and longings should actually be expanding as you are learning to hear His voice, not contracting.**

We have to experience imprisonment before we know the vastness and beauty of freedom. Imprisonment has been our backdrop for freedom. We all have experienced the oppression of bondage, both before and after knowing Jesus. We are legally free in Jesus, but like the Israelites, we often step back into the confines of captivity. But this backdrop has provided for us an immense picture of how good freedom is and what God did to close the breach between us. As you experience more beauty and freedom of worship, you realize that it would feel like death to go back into captivity. Freedom becomes familiar friend rather than foe.

Nancy Pearcey, in *Total Truth*, says, "Suffering purifies our desires."[2] What a profound statement. We all have desires: some are rooted in evil; some are rooted in godly passion. Suffering has a way of sorting and refining our longings. This is why, as we submit to Christ, we must move toward the things we are passionate

about. Our poverty will always accompany our efforts. We still dream. We still weave desires and hopes into our lives. We do this in expectant anticipation, knowing God purifies our desires. God always wants and dreams more life and love for us.

Calling

Part of the ache of engaging in the creative process, as we've discussed throughout this text, is the question of whether my offerings will be good enough. Is it really worth doing if the final product is not a success? Is it worth doing if I have not become a "great artist"? At the end of the Disney movie *Ratatouille*, Anton Ego (the food critic) says, "Not everyone can be a great artist, but a great artist can come from anywhere." The first portion of the phrase is what actually caught my attention. Our culture of productivity and consumption teaches us that if we don't land somewhere at the top, it must not be worth doing. I believe this is the crux of our wrong thinking. My friend Andi reminded me recently that we need to engage in the many callings God has placed upon our lives. Most mothers will not be recognized with prizes, honors, or money. But we mothers can operate from a secret knowledge that we shape and form small hearts that will grow up to be large hearts and bless a small corner of the world. Our callings, given by the very One who breathed the universe into being, propel us to do the things we do. Our work is to decipher our callings.

Of course, we must live within the framework of our many different callings. Throw off the lies that bombard your brain. They might sound something like this: "I don't have a publisher… No one looks at first-time authors… Do I really have anything valuable to say?… I don't have time to write"… and so on. If God has given you an ability to write, that is a calling. We put pen to paper for pleasure's sake, for His pleasure. If the words never appear on the pages of a book, you have still carried out your calling. In a recent venture, I was reminded quite persuasively that God uses callings on our lives for our redemption, and we care much more about the outcome of art than He does. I was invited to submit illustrations for a children's book (see "Emerging Creativity" at the end of this

chapter). This was way beyond my realm of experience, but I decided to leap off the cliff anyway. The writer had seasoned illustrators waiting in the wings, so I didn't want to hang up the queue for too long. About a week later, three scenes were completed. I felt like I had resurfaced from the ocean's depths, out of breath and exhausted but strangely exhilarated. The illustrations had taken me back to scenes of my childhood. As I saw myself at five, I wailed like a child and grieved as an adult. My already-absent father was, for all intents and purposes, about to leave my life forever. I don't remember the actual scene, but that night in my art studio it played out like this. I was screaming for my dad, saying things as if I could will them into being: "Come back, please. You want me, you love me. Come back." Through the begging and pleading, another voice, hanging like wallpaper in my mind, overpowered the cries: "Dry up… DRY UP!" Tears erupted for the small child forced to bury her sorrow. I spent time on that couch grieving over what was lost so long ago. I grieved over the loss of my dad. I grieved over decades of indifference and inability to feel the loss. I grieved over the way I took those messages into adulthood. *No one wants to see your tears, or experience your loss with you. Be "strong."* Don't feel. I grieved over my false notions of strength. And for the first time in my life, Jesus came into the middle of my deepest place of shame and touched it and that began a healing process.

A couple of days later as I grieved over another scene in my life, it dawned on me. I was able to talk to that little girl. In the midst of her tears, I told her she was strong! Avoiding sorrow is not strength, but walking through the fear and pain—dying an appropriate death—is where strength lies. Jesus is the ultimate demonstrator of this.

It doesn't matter if the illustrations will ever be published in a children's book. But I came to understand that for those days my calling was the interweaving of art and prayer. If you are called to the work, then do it. Enjoy it. Savor it. Don't fret about the end result. Art is a prayer… enter into the great cathedral and breathe the prayer.

Here is another way we hold the tension of life and death. I was given an opportunity to remember a time when death came. As a child, I was told to

why did God give
YOU PASSION
for these dreams?
Where is He?
What is He saying?

extinguish the longing. "Dry up. Do not grieve over your daddy." Now, when I grieve over that, I stand at a crossroads. One path continues in the direction of callous indifference. The reverse path embraces grief. Previously I equated strength with being dry-eyed. Today I see that strength lies in allowing the natural cycle of death to spring new life. But death, whether death of an enemy or friend, still hurts. Choosing life is choosing to grieve the death that leads to resurrection. This is true strength. The miracle in this is that the very place that we've been wounded can be the very place we care capable of extending gifts of healing in the world.

This week, I want you to spend time in your dreams. Dream big. Allow the Lord to show you the deepest longings of your heart. Allow yourself to explore an unfamiliar place that is familiar to God. Reaching this place may be difficult for a number of reasons: we despise our longings, we call ourselves brash for entertaining them, we think ourselves selfish for investing in them, we're afraid of disappointment, we're accustomed to deferring hope, etc. Allow yourself to wrestle through the resistance and inner arguments with God. See yourself on the other side of accomplishing your dreams. What formative events shaped your dreams? Why did God give you passion for these dreams? As you sit, imagine Jesus in your dreams. Where is He? What is He doing and saying?

You may be surprised by the potency of your dreams. Do not be alarmed... God created you. He has made you this way. Many times the injustices we experience inflame our passions. Our dreams are tied to places of sorrow. Can you meet God in those places? The goal is to discover what moves and haunts you and how God is drawing you into a deeper love experience with Him. Do you feel His delight over you? Do you feel His pleasure over you, giving you a hope and a future?

Life from the Ashes

Only in God's economy can we make sense of the mystery of death and resurrection. It is in death that we have the promise of new life. Consider a poem that illustrates this mystery:

All that is gold does not glitter,
Not all those who wander are lost;
The old that is strong does not wither,
Deep roots are not reached by the frost.
From the ashes a fire shall be woken,
A light from the shadows shall spring;
Renewed shall be blade that was broken,
The crownless again shall be king.
(*The Lord of the Rings*, JRR Tolkien)[1]

are you
FAMILIAR
with the discipline
of DELAY?

This poem speaks of Jesus. It speaks of life from unexpected places. It speaks of treasure unwanted by most. It speaks of resurrection. Smoldering ashes bring forth something of beauty. It speaks of refined faith. It gives an answer.

I am also reminded of the Old Testament story. It is a story of utter destruction because of hatred and indifference to God. Israel looked to its kings for salvation. Most kings led the people astray. Some kings desired the things of God, but no king could ultimately serve as their redemption. All was lost—everything was ash. Then, a fire was sparked! A light from the shadows. The broken line of kings wrought Jesus, the ultimate redemption! Our part of the narrative is dying to self so that the King may live in us. Dying to self does not mean dying to our dreams and longings. Dying to self is submitting to both the sorrow and the joy that our dreams and longings bring us. Look to the ashes of injustice in your life and you will find that God, in His generosity, has purposed a light to emanate from the shadows and take shape as your dreams.

Wilderness of Waiting

Sometimes God sends us into the wilderness to wait. Waiting is a very difficult thing to do, but waiting can be very active. Usually after a season of waiting, there will be new growth. But what do we do in the waiting? We plant seeds. We seek the face of God with all our heart. Sometimes waiting can bring rest and

refreshment. Sometimes waiting means tending to wounds, or learning quiet; stillness. Is your soul quiet in the middle of bustle? Are you familiar with the discipline of delay? Seeds must wait in the soil before giving life. You are not alone or orphaned in the wilderness; rather, you become more familiar with the sound of His voice. The Hebrew word for wilderness actually translates into "the place where God speaks." There is a rich depth to waiting. Are you restless, preoccupied, or trying to move past a waiting period? Waiting has purpose. We can be attentive and expectant as we wait. We usually look for results rather than being content in the presence of Jesus. As we wait in anticipation, engaged in the present moment, hearing God speak.

Coming as Little Children

To enter the kingdom, you must enter as a little child. "At that time the disciples came to Jesus and asked, 'Who, then, is the greatest in the kingdom of heaven?' He called a little child, whom he placed among them. And he said: 'Truly I tell you, unless you change and become like little children, you will never enter the kingdom of heaven. Therefore, whoever takes a humble place—becoming like this child—is the greatest in the kingdom of heaven." (Matthew 18:1-4). The question was this: "Who is the greatest?" They hoped the answer might be "the one who stuck closest to Jesus," "the one who hung up his cloak," "he who had the most knowledge," "he who knew how to manage crowd control" or "the one that Jesus consulted the most." The fact that they even asked who was greatest showed they were dutiful, glory-seeking men. Jesus told the disciples that they must have the heart of a child… not childishness, but child-likeness. A child takes pleasure in the ordinary, enjoys the glory and light of each moment; a child is not driven by duty and expectation, but pleasure and delight! Our creative process should look like children playing in the sandbox!!

This is a picture of hope—child-like delight in the beauty of the world. But, in every one of our stories, we knew we had left the Garden and experienced the world the way it really was. As children, we shored up our hearts and protected ourselves from the cold, harsh winds of the world… but we didn't yet have

our robes… we were naked. We attempted to clothe ourselves, just like Adam and Eve did; only we didn't reach for fig leaves. Other characters in the story, characters also wearing cover-ups, told us to patch our tattered clothing. "Be this person," they would say, as you ironed on another patch. "Oh, don't say or think that. That will never work outside the Garden!" Another patch. Somehow, the patchwork attempts haven't covered the shame; instead they have heaped on more shame. So the more we attempt to cover our nakedness, the more we eclipse the truth of who we truly are!

The answer Jesus gave the disciples was not about living dutifully or covering one's responsibilities. His answer was borne out of pure, sheer delight with the heart of children. You don't find children worrying how 5,000 people would be fed or the logistics of traveling with Jesus. Those aren't bad things to be concerned about. What we miss are the adventure and excitement of it. Children ask, "Where are we going next?" They want to love and be loved. They want to laugh. They are eager to experience joy and delight. As adults, it is difficult to tap into moments of joy. It is a life-line to reconnect with it though.

Richard Rohr writes, "We need rituals and ceremony to tenderly express our child-like devotion and desire."[3] Intentionally setting up a place to play is of great importance to that artist child. You could give her all kinds of excuses, but that will not satiate her need. Have you set up your sanctuary yet? Have you anointed it with a ceremony? This would be a great way to tap into your child-like heart.

In the last chapter we saw a correlation between Revelation 3 and 1 Corinthians 13. We talked about faith and refined fire. Let's look into the second offering, which is hope and white garments. Look at the remarkable text around Jesus raising Lazarus from the dead: "Jesus called in a loud voice, 'Lazarus, come out!' The dead man came out, his hands and feet wrapped with strips of linen, and a cloth around his face. Jesus said to them, 'Take off the grave clothes and let him go.'" (John 11:43-44).

What grave clothes do you insist upon wearing? What does God want to resurrect in you? Spend some time looking at grave clothes from a historical

what does
GOD WANT
TO RESURRECT
in you?

perspective. Travel back in time. Pick a specific childhood scene that brought sorrow in some way. Invite Jesus and watch the scene together. Do you see a little girl starting to wrap up some part of herself in burial clothes? These are your grave clothes. Jesus wants you to be free of the grave clothes! He wants to resurrect this part of you and see you live fully! He wants you to wear His white garments with dignity and confidence. He is waiting to put them on you… why are you hesitating to receive His provision?

I want to share an excerpt from my solitude, a conversation we had not long ago. A letter from the heart of God, to me:

You are my daughter. You have a heavenly Father that you are hidden in. I have found pure delight in giving you to My Son as a precious gift. You belong to Me and have been given, purchased and are My gift. I have been generous toward you, my daughter. Whatever you want in Jesus is yours. I want you to desire gold refined by fire, white garments and salve for your eyes. I give you a new name today. It is not what you call yourself, or what others have called you. In your lostness, be found. In your loneliness, be found. In your helplessness, I have found you. In your insignificance, I have you hidden. In your incompetence, you are hidden in Me. Be found. I have come to seek the lost. You have been lost… I have found you. You are now hidden away with Me. Be free to do the things I've called you to do under the shelter of my Refuge—My hiding place. I see you, and what I see is lovely and breathtaking. That's all that need matter. I see you… all of you… nothing is hidden from My eyes—and I see loveliness. Be fearless as you hide away in Me.

Child-like hope: When was the last time someone saw you and ran to you? Do you remember the feeling of being delighted in? This encapsulates child-like hope. We must come to Jesus in a child-like posture. We must bring Him our grave clothes. He has a royal robe for us. It's time to play dress-up and realize the longing behind our dress-up play is a true longing and it has a fulfillment!

This is our hope. We are heirs to an everlasting Kingdom. Hope is the taproot of everything we long for. It is easier not to hope; hope is irrational. It is easier to carry our grave clothes around than to reach up and hope for royal robes. Hope carries with it the ache of deferment. It would be far easier to kill our longings and dreams than to carry them. Hope invites us to suffer. Hope invites us to live. Hope says that God lives in me and there is a better day. Life springs forth from Hope. Remembrance springs forth from Hope. Real hope must be tied to reality, because hope tied to illusion is false hope. Let's wrap our hope around our heavenly clothes... NOW... before we ever settle on a "heaven" in our realm. Our hope must be tied to something that outlasts us and this world. Our hope must be tied to another world.

We filter our experiences with our outward perception of things. As children, we didn't protect our identities. When we saw something that gave us great delight, we squealed with pleasure and ran toward what we loved. As adults, we falter and filter. We preserve our identities; observing for dangers and passing over our delights. This can be our knee-jerk reaction to a past or present hurt and suddenly we're dressed in raggedy old clothing, attending to the tears with patches. Can we receive delight so spontaneously? Can we accept the Kingdom as gleeful, delighted children?

Remember a scene in which you were told you could only have crumbs from the table and never a seat at the feast. In a song, Mindy Smith sings, "Everything important leaving me, falling apart at the seams." When we wear our patches to cover our scars, it only works for so long. The stuffing starts to fall out again... everything important leaves us. Jesus says that He has white garments—He wants to heal us from false identities and clothe you with beautiful clothes, not your own tattered, torn attempts at covering over the scars.

QUESTIONS FOR REFLECTION

Day 1: Name a place in your story where you can see that suffering has "purified your desires."

Day 2: Name a place in your story where you have seen resurrection from the ashes. Call it forth and name it. Spend some time celebrating over it.

Day 3: What is THE DREAM? What is He is calling you to do with your life? What is the thing that moves you above anything else? Why do you think this is?

Day 4: How does your dream interact with your callings?

Day 5: Begin a planning chart. What is the next step to realize this dream? What's the next step after that? Chart out your movement for one full year.

Day 6: Do you believe that you are a bearer of a royal robe? Why or why not? Are you wearing it? Why or why not?

Day 7: How have your patches defined you more than your royal robe? How can the royal robe start to speak louder than the patches?

SOLITARY PERUSINGS

Take the spot that you created back in Chapter Three and create a ceremony between you and the Lord. Do something to consecrate that place as sacred. It doesn't need to be a solemn ceremony. This is intended to help you tap into your child-likeness. Do some finger painting and hang it up in your space. Make a kite there that hangs up in the corner in between flights. Anoint the doors with oil. As you set apart a place for Him in your home, you are signifying that your heart has been set apart and consecrated to Him. Delight and dance! Make a centerpiece for your table… be creative; think outside the box.

UNACCOMPANIED

Violinist, alone as on a martyr's cross,
You have forgotten us.
It's not always this way,
I've seen plenty of others playing
The audience along with the music,
But you, exposed, tortured, ecstatic—
Should we not close our eyes?
Have we the right to perceive
The blindness of you, your white face,
Badly tailored suit, awkward stance
And deeply erotic abandon, as well as to accept
This intricate energy, this weight, this outpouring
Of light which Bach
Permits you to suffer, permits you to offer?[1]

WAKING UP *grey*

Resting at the table teaches Grey about love. When she sits with her Host, she is in the presence of pure, true love. Not only does she experience its source and essence, she embraces being an object of this love. She comes to realize that her Lover has poured Himself out in every way that one could be poured out for another, all for the preservation of intimate communion at this sweet table. Where she once felt guilt and self-contempt, she now immerses herself in His mysterious love, letting it seep into every pore and crevice of her being.

nine

LOVE: THE RETURN TO SIGHT

The Mystery of Art

God is not a resource to tap so we can have some kind of creative experience or use Him to get "unblocked." The creative process is a way in which we learn who God is. We walk into the mystery of Jesus. Rather than getting something from Him, we are walking along the vast terrain that is God's heart. All the years lived on earth could not exhaust our exploration. He teaches us to want Him more than we want His gifts or a finished product.

Art is not meant to be a solution, an answer or anything complete. Art is an exploration and excavation of mystery. To excavate some of the mystery is to discover what a labyrinth of endless mystery is yet to be discovered. Mystery brings us in touch with what haunts, stirs and calls passion out of us. We tend to approach mystery intent on solving it, discovering it and bringing answers to it. Mystery disturbs our world and the way we've attempted to

129

order it. I see this being played out in the mundane circumstances of daily life. My child will get a cold or fever and my friends often respond in a sympathetic way, hoping for the sickness to disappear quickly. Of course! And that is a merciful response. But what if the hope was that we would somehow experience the goodness of God in this circumstance? We so quickly want to tie up and close off the things we don't understand or the things that seem to contradict a beautiful God. If we could enter into the mystery of those circumstances and find fellowship with God in them, to me and to you there would extend spaciousness to understand the character of God more fully. We may not get answers for our circumstances, but our trust is built, and we find ourselves becoming more colorful, compassionate people. Love for God and a desire to know Him more fully becomes our way of functioning rather than having our circumstances and questions answered, then returning undisturbed to our comfort.

We fight against the way the world was made. It is rigged with questions. We want to solve, resolve, and wrap things up. But the story has not reached a conclusion; God is still writing the narrative. We know the ending, but we don't know the mystery between the pages. We must come to a place where we can leave things open-ended. It's like we're halfway through the movie. We can't skip to the end—there are too many loose ends. For now, we may let it be a mystery and live in the tension. My pastor uses the phrase "the already and the not yet." What he means is that we are in the third age! Creation has happened. The Fall has happened. Jesus has died for us. We are now living in the Redemptive part of history in which there is an environment for both flourishing and decay. Up ahead, the story is glorious beyond our imagining. But in the third age, we groan, as Romans 8 says. Jesus has already defeated death and darkness. We already belong to Him. But today, we live in the tension of a world that is still marked and marred by the decay of the second age. This is the "not yet" of the third age. Some of the "not yet" we know! Some of the "not yet" remains hidden from us.

Jesus Is Enough

As we walk around in this life, showing up in the lives of others, we cannot help but have an impact, whether for ill or for good. When you see your impact is for ill, knowing God is sufficient is critical. A great mystery is that nothing is wasted in God's economy. It is appropriate to grieve and repent over the times you hurt someone. "Godly grief produces a repentance that leads to salvation, and brings no regret, but worldly grief produces death." (2 Corinthians 7:10) Worldly grief over one's impact for ill leads to the belief that one is either too much or not enough: it convinces that one's action (or inaction) is too great for God to redeem. Wordly grief collects in pockes of deadness within us. But Jesus wants you to be ALIVE! Godly sorrow always considers the heart and power of God. Godly sorrow releases you from unmitigated regret, meaning you believe Jesus is enough for this ill. Godly sorrow teaches us how to love, truly coming in touch with what it means to be human and therefore, fully equipped to offer a cup of cold water.

Jesus says the darkness is as light to Him; that He will illuminate the darkness. Ephesians 5:13-14a says, "But when anything is exposed by the light, it becomes visible, for anything that becomes visible is light." In Isaiah 45:3, God says, "I will give you the treasures of darkness and the hoards in secret places, that you may know that it is I, the Lord, the God of Israel, who calls you by your name." Later, in verse 7, God says, "I form light and create darkness, I make well-being and create calamity. I am the Lord, who does all these things." What is His purpose for creating opposite ends of the spectrum, and everything in between? All that we can do is ask for faith to "know that it is I, the Lord, the God of Israel, who calls you by your name." That He would go so far as to call darkness a treasure is powerful imagery about the depth of His love for those He calls by name. If this redemption of darkness could be described in color, Goethe said it well: "Violet is both a symbol of the highest rapture of the soul... as well as of its darkest and most painful moments... In its oscillations passion comes into contact with intoxication,

liberation with decay, death with resurrection, pain with redemption, disease with purification, mystical vision with madness."

What Is Strength?

Our culture is all about the strong, the talented, the powerful, the beautiful. We have large heroes. Our culture despises the little, the ordinary, the poor, the average. We reject smallness and inflate largeness to an unnatural state. It's all over the place. Look at any grocery store magazine or popular television show: America is obsessed with super-sized fame and grandiosity. Worldly strength is about money, looks, and power. Consider how Jesus would have trouble fitting America's model of strength: "But we preach Christ crucified, a stumbling block to Jews and folly to Gentiles, but to those who are called, both Jews and Greeks, Christ the power of God and the wisdom of God. For the foolishness of God is wiser than men, and the weakness of God is stronger than men. For consider your calling, brothers: not many of you were wise according to worldly standards, not many were powerful, not many were of noble birth. But God chose what is foolish in the world to shame the wise; God chose what is weak in the world to shame the strong; God chose what is low and despised in the world, even things that are not, to bring to nothing things that are, so that no human being might boast in the presence of God. He is the source of your life in Christ Jesus, whom God made our wisdom and our righteousness and sanctification and redemption." (1 Corinthians 1:23-30)

Look also at the counterintuitive description of strength Paul gives in 2 Corinthians 12:7-10, when he says, "So to keep me from being too elated by the surpassing greatness of the revelations, a thorn was given me in the flesh, a messenger of Satan to harass me, to keep me from being too elated. Three times I pleaded with the Lord about this, that it should leave me. But he said to me, 'My grace is sufficient for you, for my power is made perfect in weakness.' Therefore I will boast all the more gladly of my weaknesses, so that the power of Christ may rest upon me. For the sake of Christ, then, I am content with weaknesses, insults, hardships, persecutions, and calamities. For when I am weak, then I am strong."

Then, he goes on to say in 2 Corinthians 13:3-4: "(Jesus) is not weak in dealing with you, but is powerful among you. For He was crucified in weakness, but lives by the power of God. For we also are weak in Him, but in dealing with you we will live with Him by the power of God." Paul would've become too "elated" without the "thorn." The thorn grounded him. To walk around unbroken is to be ineffective and unidentified. To be strong in a worldly sense is to be happy and "with it," thus being void of true compassion, imagination and deep connection.

Weakness brings us in touch with suffering. The power of Christ is found in the willingness to share in His sufferings. Godly wisdom actually says that it is good for His people to suffer. It seems like betrayal, but suffering comes from His hands. "It pleased the Father to bruise His Son." (Isaiah 53:10). What?? Paul said his thorn prevented him from becoming too elated by revelations of what is to come. What?? Why isn't it good to be happy and elated all the time? There aren't any easy answers. We can see that God's people have always been "stiff-necked." The Israelites needed constant redirection, as do we. Many times, our worship of God is born out of suffering. It is the mercy of God for his people that draws us back to him. Julian of Norwich says, "First there is the Fall, and then there is the recovery from the Fall. But both are the mercy of God."2 This implies that God intends suffering in our stories. Without suffering, we would have no backdrop for words like mercy, forgiveness, and grace. All of a sudden, the chasm that the love of God must fill becomes incomprehensible: it now includes evil, ugliness and the disintegration of all that is good. His love is sufficient for that! Would we have any idea of the vastness of the chasm without suffering? I don't think so. Our human weakness is something Jesus understands. He entered into it and experienced it. That is why our strength lies in the death of Jesus and in His resurrection. We have the same calling. We have been asked to die, but not to remain in the grave!

Strength also comes through deep connection with Jesus. I love Richard Rohr's wonderful little book called *Everything Belongs*, in which he says, "The path of prayer and love and the path of suffering seem to be the two Great Paths of transformation. Suffering seems to get our attention; love and prayer seem to

get our heart and our passion."3 In this study, we've looked into each of these. I agree that suffering, love, and prayer cause profound change and new growth. When Rohr speaks of love and prayer, I believe he is talking about the kind of prayer we've been discussing and experiencing. Not the kind of prayer you mark off of your agenda; not the kind of love that sends you drifting up into the clouds of elation and disconnection from the suffering of the rest of the world. We're talking about the kind of prayer that leads to reconnection with the beautiful voice of Jesus saying you belong to His family. This is true strength. So, how does Jesus become our strength? The following are references if you have some time to study strength: Ex. 15:2, I Chr. 16:11, Neh. 8:10, Ps. 28:7-8, Ps. 46:1, Ps. 84:1-5, Ps. 119:28, Ps. 140:7, Prov. 24:5, Is. 35:3-4a, Is. 40:29-31 and Is. 41:[1b] (this is by no means an exhaustive list).

Jesus becomes our strength as we "seek His presence continually" (1 Chronicles 16:11). We come to realize, as we bring our brokenness and weakness and collapse upon Him, "His power is made perfect." He refreshes us by speaking delight into our hearts. His delight brings us joy and the joy of the Lord is our strength. So, a biblical understanding of strength opposes the worldly view. We are never called by God to "pull ourselves up by the bootstraps." That is a worldly way of being strong. Fixing things our own way is easier than allowing God to use our weakness and be our strength. Attempts at autonomy don't allow us space for knowing God or ourselves. Richard Rohr suggests that "we have no real access to who we really are except in God. Only when we rest in God can we find the safety, the spaciousness, and the scary freedom to be who we are, all that we are, more than we are, and less than we are. Only when we live and see through God can 'everything belong.' All other systems exclude, expel, punish, and protect to find identity for their members in ideological perfection or some kind of 'purity.' The contaminating element always has to be searched out and scolded. Apart from taking up so much useless time and energy, this effort keeps us from the one and only task of love and union."3

This approach to strength and weakness helps us learn to be wounded healers. Coming to a place in our faith where we realize that we need Jesus today,

as much as we ever did, helps us in our dealings with the pain and suffering of others. We understand because we are acquainted with it ourselves. Hebrews 5:2 says, "He can deal gently with the ignorant and wayward, since he himself is beset with weakness."

Sleepwalking

As we learn more about connecting deeply with Jesus within the backdrop of solitude, it becomes appropriate to call ourselves those who have been awakened from sleep. The writers of *The Matrix* understood this:—most of us walk through life as sleepwalkers. To make time for silence and solitude is to slowly come out of our dream-like existence. Listen to Jesus' charge to us in this parable: "Then the kingdom of heaven will be like ten virgins who took their lamps and went to meet the bridegroom. Five of them were foolish, and five were wise. For when the foolish took their lamps, they took no oil with them, but the wise took flasks of oil with their lamps. As the bridegroom was delayed, they all became drowsy and slept. But at midnight there was a cry, 'Here is the bridegroom! Come out to meet him.' Then all the virgins rose and trimmed their lamps. And the foolish said to the wise, 'Give us some of your oil, for our lamps are going out.' But the wise answered, saying, 'Since there will not be enough for us and for you, go rather to the dealers and buy for yourselves.' And while they were going to buy, the bridegroom came, and those who were ready went in with him to the marriage feast, and the door was shut. Afterward the other virgins came also, saying, 'Lord, lord, open to us.' But he answered, 'Truly, I say to you, I do not know you.' Watch therefore, for you know neither the day nor the hour" (Matthew 25:1-13). He ends the parable with this command: "Watch therefore." How can we be watchful if we're sleepwalking? How can we see God and hear Him if we haven't drawn near? A dear friend of mine asked me about this parable and wondered aloud about her oil. She asked me, "What oil have I given away that I was to keep for the Bridegroom alone?" The wise did not share their oil, for it was never intended to be shared. I wonder if the oil in this parable represents our hearts' worship. When have you freely given your oil

away? What places have you brought light and warmth to, exalting them higher than Jesus? Jesus called the hoarders wise, for the oil was designated for His altar alone. There are some things that are not meant to be given away.

I had a crisis of faith recently in response to this parable and some other circumstances swirling around me. I was reading in Jeremiah. The text of Jeremiah can send the strongest, most confident disciple hiding away, looking for an escape from the Most High! Fear gripped me as I closed my eyes and saw myself at the door that was shut to these virgins, being among them and the least of them. I was the irresponsible one, showing up late with nothing in my hands. I was not prepared for the wedding or the feast. I stood there, clamoring at the door, pounding on it and begging for someone to open it. I looked through the door and on the other side, I could see the Bridegroom and He was unaffected by my clamoring. It was as if He didn't even hear my cries. He wasn't judgmental, disdainful or repelled. He simply did not respond. This sent me into despair, wondering if I really had heard His invitation at all!

After experiencing that scene, I came to Jesus in the solitude and asked Him about it. Here's the journaled conversation we had: (His voice in italics)

"I'm knocking at the door—knocking until my knuckles bleed. I'm afraid you'll never let me in. I'm always on the outside. I'm afraid today. Am I really your 'Beloved'?"

The human condition is the same today as it was in the time of Jeremiah. Your fear of not being acceptable to perfection tears at your heart. My people back then allowed that fear to carry them away to other "gods" who would "accept" them in their defilement. What they didn't understand was that obedience is better than sacrifice. It requires the ability to look at your own neediness and come before Me naked—which is no small thing! But it allows you to come to Me with nothing and receive. You have nothing – and because of that fact, you have the very riches of God. Jeremiah's people went to other gods because all the other gods required was that they bring something. My requirement is that you come with nothing! It's easier to

come with something. It becomes about you and what you have rather than seeking Me and what I have. I am generous and everything I have belongs to you. Drop everything at the door and come to Me. Drop it and come with nothing. Your earthly fathers would teach you that your value lies in what you're bringing to the door. I run to the door to welcome you in. Drop your "things"—they are not the key to opening the door. The key to the door is empty hands. You think your gifts are what make you worthy to walk through the door; that your oil is your worthiness. You are worthy to come in because of Jesus! He has made it so by taking up your cause. Jesus has become the Door for you. He has bestowed you with the gift of oil. Even the oil of worship is a gift from My hands.

Love Is Sight

The third item from Revelation 3 and 1 Corinthians 13 is love that comes from restored sight. We need to receive from Jesus salve for our eyes that we may see. When we see, we love. When we love, we bring light.

Below I want to share with you a conversation I had with Jesus in solitude (His voice in italics). It was a day of wrestling with trust. I needed the reassurance of a Father who wanted to see and hear me. He knew what I needed and gave it to me in abundance.

"How is Your grace strengthening me?" *By standing at the table and serving you as you sit.*

"You serve me at the feast?" *Your refreshment comes from me. I give you what your soul needs. You have served and refreshed others faithfully; that is lovely to Me. You may be served, too. I care about your rest. You are My child.*

My Spirit is the breeze in your hair. You have the freedom to refresh others with the promise that you, too, will be refreshed. The Spirit is your friend. You're on a journey that is sacred. Keep moving as I meet you. You are beautiful and I am proud to call you mine.

"How are you challenging me to understand your grace more deeply?" *You're moving in it... keep moving in it. Live it, breathe it; make it life for you and those you come in contact with. I am committed to glory. I will reflect it in you. Don't lose your center. Sit in it. Draw from it... it is for you. Make way for newness of life to emerge. Dawn is coming. You are resurrected with Me and I am committed to bringing you new life and the richest of fare. Patches of Godlight will make way for full brilliance. I adore you, my dear one! I rejoice over your journey. I'm moving you toward truth... more truth... more beauty. Be with Me! Meet with Me in your inner sanctuary. I am always there. Be with Me more in that place. I have good, true and beautiful things for you to behold. The pockets of deadness are life to Me. I will restore those. I illuminate the darkness. Don't be afraid of the dark. I have overcome it. It has no power over you. Do not be ruled by it or defined by it. See beauty! See light. See good. See dark, too, but it's not the whole picture. To see light brings joy and singing. I delight in you! You are faithful. I am safe insofar as I am trustworthy. I am not predictable. I am mysterious; but, I am trustworthy. And I will let you in on some of the mystery as you learn trust.*

"What does it mean to trust?" *It means that I intend your good. You must know this. I will do good in you and for you, beloved. You must trust... that I love you!!*

"Why do I feel like you are randomly indifferent?" *This is not the truth. I am not indifferent to you... you would rather Me be indifferent to you.*

"What is the truth?" *I am not indifferent to you. I sent My Son for you! ...because I wanted to be with you! ... My beloved! I love you with an everlasting love. I'm not manageable for you because love is not something you can manage. It is wild, free, fantastic, whimsical, passionate; it makes you do things that don't make sense. That kind of love is what I have for you. I was crazy for you! Jesus came to show you exactly how far My love for you would take Me. INDIFFERENCE? You're just comfortable with*

indifference. On one hand, if you're invisible, it will cost you nothing. No offering, no suffering. On the other hand, you desperately want to be known; and in the knowing, be loved. But, being the invisible one all your life, to be known feels very unsettling. But, I know you! I know you so well, I'm telling you about yourself! So, it's too late; you're known and you are loved. You are a treasure. I'm singing over you; I'm your Abba! What you didn't have in a daddy... yes, this was ordained by Me to create this lovely being. Look at your story. I'm woven throughout... I wrote a story—just for you. Just your story. Your story has dark places; placesof deep pain and woundedness that I am working out now, even now. Because I ordained your story and there are places of pain doesn't mean I can't be trusted! It means the story is not yet complete ... You are assured of the ending. What a rich tapestry I am creating! I'm redeeming those places of lostness and pockets of deadness. Remember, darkness to Me is the same as light. O, My dear who longs to be a daughter, but best knows how to be an orphan...collapse on Me and find rest! Find rest today. I am for you... words of life!

Our sight is a gradual clearing of the lens. We need help to see. Our eyesight is part of the redemption story. Our return to glory is a journey. Our return to proper vision is a journey. When I was in New York City with my friend Tamara, I experienced this gradual restoration of eyesight. We were staying at a hotel in the city on the 46th floor. The first night there, we were awakened in the middle of the night. It was about 2 a.m. and I heard a woman yell, "Helloooo." I had never been in New York before and thought to myself that this must be what people mean when they talk about how strange city people are. She then yelled, "Fire!" That seemed a bit more alarming than strange. I sat straight up and noticed red swirling lights reflecting on the curtains. Great! FDNY downstairs. Tamara sat up as well. I got up and felt the door to see if it was hot. It wasn't. I looked out the door and the hallway was filled with smoke. I ran back in and surmised, "I think we need to go." She said, "Are you sure?" "Pretty darn," I replied. She fumbled for her glasses. I ran to find the

do you feel the joy
JUST SITTING?
being in the presence
of God without doing?

red dot on the map on the door that says, "You are here." I could not find it so I looked for my coat. I could not find it. I went back to looking for the red dot. I never did find that thing! Tamara had emerged from bed; neither one of us had located a coat (it was February in NYC). I hastily ordered Tamara to hurry. We finally made it into the hallway where a frantic woman declared that we would die of smoke inhalation if we didn't have something over our mouths. Tamara disappeared back into the room and emerged minutes later with damp washcloths. We got to the stairwell, which was clear of smoke and people. My thumping heart started to calm as we received more information. We proceeded to scurry down 46 flights of stairs, joined by another person here and there. We made it outside of the building and around the corner to the lobbyentrance. It became apparent that we were out of danger when we saw the lobby full of people, including New York's Finest with all 3,000 pounds of gear about them. But in the beginning we were working with limited sight. We didn't have the full picture—it really felt as if we were operating in the dark. As we walked into the lobby, things became clearer; but up on the 46th floor, we didn't know anything other than what was right in front of us. As we gathered more information, we were able to see more clearly how to respond. We saw they weren't evacuating; we saw NYC firefighters and heard communications. We saw more clearly and more clearly and more clearly the further along we went. This is not instant vision; this is a journey with Jesus, as He slowly pulls back the veil of our blindness. Let's take His counsel and let Him be eyes for us. "Be thou my vision, O Lord of my heart."

The fire turned out to be a short in an electrical closet that was easily contained. We say, *Carpe diem; seize the day. Make the most of every opportunity.* I love these phrases, but I also sense that we need caution in them. In order for us to see properly, we must be with Jesus. If we say "Carpe diem," the danger is that we get up and start doing… we become people of action. We move and abound in good works… great, right??? If we haven't been with Jesus, we are unsure of our calling and we scramble and muster and create chaos and urgency in our wake. We move into places that have never been sanctioned by God. Without

proper sight, we start to feel like hamsters on the wheel… running, running and running… we just keep running without getting anywhere. All we do is wear ourselves out, not to mention those around us. We expect them to either help spin the wheel, or, dang it, just jump on the wheel and start running with us! Our callings don't look like this. There is a purpose; history is going somewhere. There is a finish line. We are not doing for the purpose of doing! If you're doing things out of duty, then you are on a wheel that will continue to spin without going anywhere. If you are doing things out of calling, your sight carries you into the distant land. The things you are doing now bear fruit that you will taste in that distant land! Sometimes the best thing we can do for a season is to stop doing and just "be" for a while. Have you "been" in the presence of God? Do you feel joy just sitting, being in the presence of God without doing? Do you feel guilty when you sit still and bring the essence of your heart into the presence of God? You will not recover proper vision without being able to sit and be still before God. The salve Jesus speaks of here is the ability literally to close your eyes and cease from doing anything with them for a time. To give them rest and a time of recuperation from all that they've seen. To come into His hiding place and receive care from the toxins and wounds you have absorbed. The things that Jesus wants to give us are good things: things that heal, clothe, delight. He wants to care for us, those who have been bloodied in this battle. The battle in which we fight for our very lives and the lives of others… the others we love so much. What is keeping you from receiving care from the One who holds His hands out in healing?

Nancy Pearcey describes restored sight this way: "If we long to be given the mind of Christ, we must first be willing to submit to the pattern of suffering He modeled for us. We should expect the process of developing a Christian worldview to be a difficult and painful struggle—first inwardly, as we uproot the idols in our own thought life, and then outwardly, as we face the hostility of a fallen and unbelieving world. Our strength for the task must come from spiritual union with Christ, recognizing that suffering is the route to being conformed to Him and remade into His image."[4] This is why we resist the artistic process. It

has the qualities of preserving His image in us as we submit to the depths—it's the process of sight!

Silence, solitude, music, art and creativity are part of our restored vision. Richard Rohr says if we don't have these things, our emotions deteriorate into sentimentality.3 Sentimentality is really nothing more than the haze on a lens. Sentimentality is a dulling of emotions… it's a cheap knock-off of deep, moving emotions. What causes you to be in touch with the emotions that change you? I believe that your creative process puts you in touch with the deep—experiencing solitude, hearing a song that moves your soul, seeing a piece of art that captures what you knew was there but couldn't describe. These experiences, whether it is your creative process or someone else's, become sacred because they are about restoring vision. Look for His image carved upon your face and the face of others, even in the midst of marred and tainted fragments.

QUESTIONS FOR REFLECTION

Day 1: What is a question mark you've been living with that you want a conclusion to? Do you need the answer? How would you view God if it remained ambiguous for a longer time?

Day 2: If sight is a gradual clearing of the lens, how would approaching life with open-endedness change your actions, behaviors and attitudes?

Day 3: In art, what is the value of leaving mystery within a piece? In life, what is the value of mystery?

Day 4: What altar have you anointed with your oil other than the altar of
 Jesus? Where/on whom have you spent your oil that is intended for
 Jesus alone?

Day 5: Jesus said, "The Holy Spirit will take what is mine and declare it
 to you." What does this declaration mean to you? What has been
 declared as yours? Do you believe this? Why or why not?

Day 6: How is indifference an enemy of love? How does Jesus answer the
 threat of indifference?

Day 7: How do offering and suffering play out in your creative life? Why do
 these go together?

SOLITARY PERUSINGS

Scan your world today. Write down everything you see that reflects God's image.
Scan for God's beauty… look, listen, reflect, touch, ponder, smell Collect things
that reflect God's beauty. Start a small collection of things that YOU see that
reflect God's beauty. Stones, leaves, pressed wildflowers, a drawing from your
child, etc. Why does this reflect God to you? Is it something that He made? Is
it something someone else made? Construct words to describe why a particular
object reminds you of the Lord; it can be a poem, a lyric, a short story or simply

a statement expressing the truth of God through His creation. Spend some time in worship in the solitude today.

EVERY LITTLE THING

Paint me a canvas with the worries of your world
Make the colors stand out strong the way they call to you
Don't be afraid your honesty will be too much
Take a risk, break every rule to set your sorrow free
Paint for me, let me see
Every little thing that gets you down, that makes you weep
We'll search your heart out like we're diving for a treasure deep
Pour it through your hands and trust that I will understand
It's love's discovery, not for someone's gallery
Paint for me
Write me a stanza that will say what you would say
If you knew somebody would listen and offer grace
Don't lift your pen until the thought comes to an end
You just might find the lines will lead to clarity
Write for me, let me see
Every little thing that gets you down that makes you weep
We'll search your heart out like we're diving for a treasure deep
Pour it through your hands and trust that I will understand
It's love's discovery, not perfect poetry
Write for me, write for me
Come out to dance and sing
In a melody of movement
Where tears turn into joy
You were made for this

To be free and be alive
You don't have to hide
Don't keep your song inside
Tell me every little thing
Words and music by Anadara Arnold

WAKING UP *grey*

Grey threw back her head and laughed at the days to come. Grey had come far from the place where no laughter could be found. It was all because the Master broke in and rescued her from the grey prison. She laughs now, but sorrow will come again. She knows she must confront the pain to reach the light, but fear speaks a little more softly. She understands that sorrow and darkness add to the depth of the narrative. She understands that God brings dignity to her fragility and her portion of loss. In order to live, she must die to herself. It is the way of the Master. She doesn't always understand His ways, but deep trust in Him spills over to laughter, even through tears. She has so much to know and do and be; all the while, sitting at the Master's table.

ten

REMEMBRANCE

"Do all that is in your heart, for God is with you."
(1 Chronicles 17:2)

Nathan said these words to David in response to David's observation that he was living in a house and God was living in a tent. Then God's response was that he was going to build David a house, namely, Jesus. God expanded David's vision beyond bricks and mortar. He promised David that one of his sons "…will build a house for me, and I will establish his throne forever. I will be his father, and he will be my son. I will never take my love away from him, as I took it away from your predecessor. I will set him over my house and my kingdom forever; his throne will be established forever." (1 Chronicles 17:12-14, NIV) David envisioned a glorious dwelling place for the Lord—instead, God promised the Cornerstone, more than we could ever conceive of. David spent a lifetime planning and saving materials: gold, silver, bronze, iron,

stone… marble, wood, cast metal, carved images, linen, purple, crimson, blue fabrics, engraving, precious stone. It is a metaphor for the preparations God was making to build His eternal dwelling place. Neither house (the temple or Jesus) would David see in his lifetime, but he pressed on with the hope of things to come. David had purchased gold refined by fire, and held it tightly. It compelled him to "do all that was in his heart." What treasure has God placed in your heart? What do you long for? How has suffering purified your longings?

Courage

Sometimes our courage wanes and our faith wavers. We doubt the purpose of our labor, our self-care, and even our play. In our uncertainty, we delay. In our forward steps, preparation must morph into action. We must shift from a theoretical stewardship to an experiential stewardship. This is when self-sabotage rears its ugly head. We find ourselves reasoning why we shouldn't make the phone call, schedule the appointment, purchase the supplies, or the most frightening of all, sit down and do it! We need to feel safe, secure and accepted; this MUST come from the only person who can grant these: Jesus.

"Therefore do not throw away your confidence which has a great reward. For you have need of endurance, so that when you have done the will of God you may receive what is promised. For,

'Yet a little while,
and the coming one will come and will not delay;
but my righteous one shall live by faith,
and if he shrinks back, my soul has no pleasure in him.'

But we are not of those who shrink back and are destroyed, but of those who have faith and preserve their souls" (Hebrews 10:35-39)

The language of "shrinking back" catches my attention. Why would we be encouraged not to shrink back? When things get hard, our natural inclination is withdrawal. But the faith road says, "I will not shrink back." The faith

road requires that we choose to love. When we choose to love, we die to self. When we die to self, we learn how to suffer. On the faith road, we also risk life! Observing Jesus in the garden on the night before His death, we see what living by faith looks like. Jesus asked that the cup pass. There is a difference between shrinking back in fear and asking God for a different cup. Of course we don't welcome suffering. We don't jump for joy at our next round of affliction so we can be spiritual heroes at the end of the day. Our suffering is too real for that kind of show. Our suffering is also too real to minimize. Like Jesus, we accept the will of God by taking the cup. Taking the cup means receiving answers to prayer regardless of how it is answered.

If you must, ask God for a different cup. In the garden, God's answer was that Jesus must drink of the cup. We know how beautifully and perfectly the Son submitted to the bitterness of that cup. We, too, may be called to drink a bitter cup, and yet it spills out the aroma of Christ. It is a profound mystery. The sweetest offerings are often accompanied by suffering. As you create, do not shrink back. Pray through it as you take the cup God has for you.

Faith requires great courage. Courage, as defined by Webster's, is "the attitude of facing and dealing with anything recognized as dangerous, difficult, or painful, instead of withdrawing from it; the quality of being fearless or brave; valor." Notice, this definition does not say courage is the absence or opposite of fear. Fear and courage can co-exist. One typically overpowers the other. We are at a place in our creative journeys when we come to the edge of the cliff. We are either consumed by fear and turn around, or we jump. Let this be the hour when we jump, hands clasped together, finding ourselves defined more by courage than by fear.

What I am talking about here is empowerment. I must make it clear that empowerment as an artist doesn't lie in our human attempts at overcoming odds and fear. It lies in viewing ourselves through the correct lens; namely, the Beloved of God. This life-giving identity and all its implications empower us to hold our fears, obstacles, and longings—everything that we are—and help us move through the Grey into fulfilled callings of creativity. An artist's life

is lived in the tension of the din and fray of life; not the ever illusory line of "victory." I am reminded of a popular phrase used in Christian circles: the concept of a "victorious Christian life." Jesus says, "Take heart; I have overcome the world." We tend to make the mistake of "overcoming the world" by living above it or autonomous from it. That is our false sense of victory when we have successfully avoided or brushed off the rubble and debris of the world. Instead of being "in the world and not of it," we remove ourselves from even being in it. This is not the life of Jesus. To have two feet firmly planted on this earth is to live in the tension of the world. This is what Jesus did and how He overcame. He engaged His world. He did not "rise above it all" as we are often instructed to do.

Here is the passage of God's commissioning of Joshua: "After the death of Moses the servant of the Lord, the Lord said to Joshua the son of Nun, Moses' assistant, 'Moses my servant is dead. Now therefore arise, go over this Jordan, you and this entire people, into the land that I am giving to them, to the people of Israel. Every place that the sole of your foot will tread upon I have given to you, just as I promised to Moses. From the wilderness and this Lebanon as far as the great river, the river Euphrates, all the land of the Hittites to the Great Sea toward the going down of the sun shall be your territory. No man shall be able to stand before you all the days of your life. Just as I was with Moses, so I will be with you. I will not leave you or forsake you. Be strong and courageous, for you shall cause this people to inherit the land that I swore to their fathers to give them. Only be strong and very courageous, being careful to do according to all the law that Moses my servant commanded you. Do not turn from it to the right hand or to the left, that you may have good success wherever you go. This Book of the Law shall not depart from your mouth, but you shall meditate on it day and night, so that you may be careful to do according to all that is written in it. For then you will make your way prosperous, and then you will have good success. Have I not commanded you? Be strong and courageous. Do not be frightened, and do not be dismayed, for the Lord your God is with you wherever you go." (Joshua 1:1-9)

"Do not be frightened and do not be dismayed." "Be strong and courageous." These commands presuppose that the Promised Land was full of danger. It is like that with any journey that leads to the fulfillment of our dreams. God's people dreamt of the moment their feet would cross over the Jordan. They had been in the wilderness all their lives. They buried the generation that escaped Egypt. They wanted the land promised to them, but knew they were in for a fight. It would've been safe to stay in the wilderness. I'm sure some of them made their voices heard in that direction. The Lord understood that they needed resolve in the face of fear. We need that same resolve today.

Discipline

We do lack discipline at times. I'm not advocating becoming rigid, task-oriented, or legalistic. But, sometimes, discipline and decadence can be disproportionate in our artistic lives. As we explore creativity it is important that we do not do things out of a sense of duty and kill our joy! However, it may be prudent to look into ways that we can measure our steps and see some success. Disciplined activity can spur us on to taking more steps toward authentic reckoning.

Celebration

Are you celebrating the work He is completing in you? You are not who you used to be. Celebrate! You're not what you will be. Kill the fattened calf! Jesus is committed to you. He is not leaving. He is not indifferent to you. He has brought you to this place in your journey because He wants to see you liberated unto the end that you will bear His image all the more fully in the days to come! This is cause for great celebration!

Have you ever noticed after an important accomplishment how exhaustion and feelings of melancholy can set in? We need rest after a growth spurt has taken place. Pay attention to this. Grief happens when we experience loss. Growth and change can feel like loss. You've made a choice and died to other paths. Choosing to do things differently is often painful. Doing something outside the status quo is usually full of tension. So, after you've experienced transformation through

suffering, grieving may be the most natural and appropriate thing to do. Allow yourself that freedom. I'm not talking about isolating yourself. Lean into your community and those who champion your work. Stay close to the banqueting table and dine with those gathered around the feast. Remember that your rest and refreshment are important to Jesus. It is good to rest.

When you have grieved and moved through a loss, oh what a time for celebration! Mark the moment. Create a ritual as a remembrance of the work God has done in you. Ritual and tradition are beautiful ways of marking such events. Invite everyone over to dance in your living room. Have a "show and tell" evening with your creatively supportive friends. Invite them over for a gourmet meal (or meet them at a gourmet restaurant!) and share the hard work you have done. We have a creator who loves to mark triumph in this way. The Old Testament is filled with feasts and celebrations marking the faithfulness of God. This celebration marks the faithfulness of God to complete His work in you. Remember your story... it is the essence of your strength. "Therefore do not throw away your confidence which has a great reward." (Hebrews 10:35) The confidence the passage speaks of is a sweet confidence that comes from remembering. You have a memory of God meeting you. From that we become the remembering ones.

Remember your story. Choose a part of this journey that you've been on and commemorate it in some way. Have a drawing framed. Make some homemade paper and pen on it some of your important accomplishments and benchmarks.

Community

Autonomy, individualism, and self-sufficiency epitomize western culture. These values lead to isolation, loneliness, and despair. Ours is a culture conducive to plunging into the depths alone and staying there for a very long time. We either come out for brief moments and assure people that everything is fine, or we don't show up at all (and no one asks about our poor attendance). Our lives are fragmented and disconnected from one another. This is something I struggle with.

I heard a story the other day in which someone had just come out of a counseling session with her husband. It was more like a boxing match. They aired out everything in that hour—all the marital pain and betrayal they had caused each other. It was a bloody fight. Unexpectedly, a friend was waiting for her afterward, insisting that she take her home. In tears and unable to protest, she humbly accepted the company. They drove to a house where a group of friends had gathered to enter into her grief and pain. They sat in the kitchen and wept together. This story struck me to the core of my being. I was astonished that a group of friends would take such severe pain and make it their own. They didn't try to fix it. They didn't dumb it down or bypass the discomfort by movingon to something more comfortable. They gave her the gift of sharing in her pain. They gave her hope for a better day. After hearing that account, I grieved for several days. I have never been able to let people in to that degree. I can be on the other end. I can be moved and haunted by someone else's story. But I have been stunted in my willingness to let others into mine. I was taught at an early age that my needs were cumbersome and inconvenient. I was censored and stifled because my emotions were unmanageable. I learned to be self-sufficient and trust only myself. I marveled how my friend could be so openly vulnerable with her pain. After hearing her story, I felt a huge loss. Would I ever be able to hand something so sacred over to others?

What does your own story tell you about living in family and community? We have wounds when it comes to living in community. We take preventative measures to protect ourselves from further letdown. We are wary of others. So, we cloak our fears with words like autonomy and individuality. Our autonomous lives are lengths we've gone to in order to create an acceptable way of being with people on a superficial level. Living in community is messy. It may require more of us than we are willing to give. We prefer the culturally accepted option of remaining disconnected. What treasures we miss! I was so haunted by my friend's story because it is what I long for. It's a small taste of Garden intimacy. I've known very well the kind of pain she felt that day. But my grief has always been a solitary journey. I can talk about my grief, but to grieve in the presence

of others is rare, at best. This should not be. As creative beings, we need to share in one another's stories. We need each other to speak into the places where truth has been scattered.

Creativity Showing Up In Our Culture

What is creativity? It is connecting the gospel into present reality. The gospel is relevant in our daily lives. But the world is fragmented. There is a sacred and secular dichotomy. Why is this? It seems that the culture, including Christians, has sanctioned this reality. We go to church for spiritual inspiration and nurturing. But for too many, Sunday worship has little relevance outside church walls. This should not be. Every part of our lives is spiritual because we are created so. We have a strong biblical admonition to worship God in spirit. By preserving the secular/sacred dichotomy, we do not allow the gospel to change the way we parent or relate to our spouses and co-workers. Film, television, music, literature, art, and architecture belong largely to the secular realm.

We have Christian music, Christian radio stations, Christian books, Christian buildings, Christian schools, and Christian ministries. No wonder the question of relevance comes up. The Christian is irrelevant to those in the secular realm. How God will be honored when the secular and sacred collide! What an opportunity in this space and time for God's people to infiltrate society and bring truth and beauty to bear—not by condemning the dark places, but by entering into them and illuminating them with glorious truth and relevance.

As Christians, do we believe that we have a message of hope and truth for the world beyond our subculture? I believe this is where the break-down is. We don't believe it for our own lives or the lives of our fellow believers. Is God's story relevant when your best friend has confided in you that her husband is abusive? Is it relevant when you decide that today will be a day free from alcohol? How does the gospel impact the story of men abusing women through Internet pornography? Where is the gospel when the story is a chemical imbalance and no treatment is available? How does the gospel compel us to enter into a friend's

deep sorrow? Does it? I pray we learn how to reflect the power that the gospel has in our art and connect our art with the secular world.

Stories of redemption need to be told and heard to show what the resurrection power of God's story is doing. We learn to compartmentalize our faith. We don't take it with us as we do breathing. We take it where it is acceptable to bring it: church, certain relationships. Remembering God's faithfulness before others is the power of the Gospel. Remember God's faithfulness in your art! Tell your story of redemption through your art.

Have you noticed that during the course of your time in *Waking Up Grey* that many facets of life have turned upside down? This is because life is a series of altars. Rebecca Wells, author of *Divine Secrets of the Ya-Ya Sisterhood*, also wrote *Little Altars Everywhere*. I liked that book, but what stayed with me was the title. It affected the way I view life: We have been created to worship, but the Fall distorted what we worship. Intentionality is required now to orient our hearts to worship God. As we look into our creative lives, we learn that all of life can be a piece of art. My dear friend Sharon said to me while going through this material, "I am the piece of art." That struck me so profoundly. I realized that as we recover more creativity, our lives start to become a series of little altars everywhere. All of life is an act of worship. Each facet can sing of art, set up as an altar of worship and the aroma of Christ. Marriage, raising children, household management, employment, chores, leisure time, and of course, creative endeavors are transformed as we view them as opportunities to worship and bring beauty.

I want to send you off with a couple of cautions. As I stated above, many tiers of your life may have taken on new shapes. As a result, you may be experiencing new tensions in relationships. Or you may be reaching a new levelof intimacy in other relationships. Regardless of whether the transformation has met with celebration and excitement, or tension and resistance, it is still a transformation which God intends to be regenerative for you!! This is hard work you have done and He is celebrating! I encourage you to continue to fight for those relationships in which there is heightened tension. All we can really do is act as a gatekeeper, as my dear friend Carole says. She describes it as standing at the gate of the

pasture, and simply telling those we love, "He's in there; He's waiting for you." We can't push or pull or drag them into the pasture. But we can, with prayer and hopefulness, echo the invitation that Jesus Himself is extending.

Secondly, your creativity does not define you! As Os Guinness says in his marvelous book, *The Call*, "There is no calling unless there is a Caller."3 The Caller is the One who defines you and gives you a name. Your creativity will betray you if you are looking for it to name you. Guinness puts it this way: "We are not primarily called to do something or go somewhere; we are called to Someone. We are not called first to special work but to God. The key to answering the call is to be devoted to no one and to nothing above God himself."2

QUESTIONS FOR REFLECTION

Day 1: Celebrate!! You have pressed through to the final chapter! Go have some chocolate and java as you list in your journal creative milestones achieved during this study. Take inventory and celebrate over the rough terrain you have traveled!

Day 2: "Do all that is in your heart, for God is with you." (I Chronicles 17:2). God is saying these words to His servants today. Do you believe this? How will these words impact your planning chart from Week 8?

Day 3: How do courage and faith work together to prevent you from shrinking back from doing that which God has laid on your heart?

Day 4: How does autonomy in today's culture assault community? Has it kept you isolated? How?

Day 5: How would your personal worship change if you viewed worship as a series of "Little Altars Everywhere"?

Day 6: Listen to the song *Every Little Thing* (found at Anadara.com or included as a bonus CD. If the song is unavailable, you can read the lyrics at the beginning of this chapter). What about this song speaks to you? Look at the invitation you did in Chapter One, along with the table you made in Chapter Three. Journal about "love's discovery." How have you "discovered" more of God and yourself through this invitation and sitting at the table? Partake of the elements at your table and celebrate with Jesus the feast that's been made possible.

Day 7: Make a plan for continuing to show up at the table.

SOLITARY PERUSINGS: FAITH BUILDING

I want you to bring your community into your perusing by creating some sort of ceremony. Invite those who defend your creative work to celebrate with you. If you like to cook, invite them to a feast. If you love chocolate or java, meet them at the café downtown. My friend Andi has a disco ball in the middle of her

great room and every Valentine's Day, her family gathers to celebrate through a lavish dinner and dance. They mark a day in which rituals become celebrations of relationship. You have done hard work, and those who love you want to celebrate over your journey. Make it splendid. Whatever you choose to do, create an intimate setting where you can share with your fellowship what roads you have traveled. Be specific with them. List at least five major accomplishments you have completed during this course. Maybe you took an art class. Maybe you grieved over the death of a parent for the first time. Maybe you had a difficult conversation with an old friend who wounded you creatively in the past. Maybe you're learning to respond to the Master's voice. Maybe you called yourself an artist for the first time. These are all significant moments that need to be remembered and celebrated with those who have walked with you. Plan the day. Make invitations. Enjoy the gifts that you receive as you go about the preparation to mark these moments.

ENDNOTES

Chapter One

1. Andi Ashworth, *Real Love for Real Life: The Art and Work of Caring* ©2002 WaterBrook Press, Colorado Springs, CO. All rights reserved.
2. Anthony J. Hoekema, *Created In God's Image* © 1986 Eerdmans: Grand Rapids, MI.
3. Richard Rohr, *Everything Belongs* © 2003 The Crossroad Publishing Co.
4. Henri J.M. Nouwen, *The Return of the Prodigal Son* ©1992. Used by permission of Doubleday, a division of Random House, Inc.

Chapter Two

1. Dr. Daniel Doriani, Lecture on: *The Glory and the Shame: Untangling Identity, Work, Excellence and Failure*
2. Hoekema, *Created in God's Image*

Chapter Three

1. Dietrich Bonhoeffer, *Life Together* ©1954 by Harper & Row, Publishers, Inc. All rights reserved.
2. Rohr, *Everything Belongs*
3. Julia Cameron, *The Artist's Way* © 1992, 2002 by Julia Cameron, Penguin Putnam Inc. All rights reserved.
4. Fyodor Dostoyevsky, *The Brothers Karamazov*

Chapter Four

1. Nouwen, *The Return of the Prodigal Son*
2. James Finley, *Thomas Merton—Merton's Palace of Nowhere*, Notre Dame, IN: Ave Maria Press, 1978, pp. 34,36
3. Brennan Manning, *Abba's Child* ©1994. Used by permission of NavPress—www.navpress.com. All rights reserved.
4. C.S. Lewis, *The Chronicles of Narnia: The Voyage of the Dawn Treader* © 1952,
 Macmillan Publishing Co.
5. Victor Hugo, *Les Miserables* © 1987 Published by New American Library, a division of Penguin Putnam Inc. All rights reserved.
6. Rohr, *Everything Belongs*

Chapter Five

1. Hoekema, *Created in God's Image*
2. Cameron, *The Artist's Way*

Chapter Six

1. Cameron, *The Artist's Way*
2. Don Richard Riso with Russ Hudson, *Personality Types: Using the Enneagram for Self-Discovery* © 1996 by Don Richard Riso, Houghton Miffl in Company.
3. Manning, *Abba's Child*
4. Dan Allender, *The Wounded Heart* ©1995 Used by permission of NavPress—www.navpress.com. All rights reserved.
5. John Shea, *Starlight* ©1993 New York: Crossroad.
6. Nouwen, *The Return of the Prodigal Son*

Chapter Seven

1. Frederick Buechner, *A Room Called Remember* © 1984 by Frederick Buechner.

2. Hugo, *Les Miserables*

3. Rohr, *Everything Belongs*

Chapter Eight

1a. Excerpt from *The Return of the King* by J.R.R. Tolkien © 1955, 1965, 1966 by J.R.R. Tolkien. 1955 edition © renewed 1983 by Christopher R. Tolkien, Michael H. R. Tolkien, John F. R. Tolkien and Priscilla M.A.R. Tolkien. 1965/1966 editions © renewed 1993, 1994
by Christopher R. Tolkien, John F. R. Tolkien, and Priscilla M.A.R. Tolkien. Reprinted by permission of Houghton Mifflin Harcourt Publishing Company. All rights reserved.

1b. "All That is Gold" from *The Fellowship of the Ring* by J.R.R. Tolkien, © 1954, 1965 by J.R.R. Tolkien. © renewed 1982 by Christopher R. Tolkien, Michael H. R. Tolkien, John F. R. Tolkien and Priscilla M.A.R. Tolkien. Reprinted by permission of Houghton Mifflin Harcourt Publishing Company. All rights reserved.

2. Nancy Pearcey, *Total Truth: Liberating Christianity from its Cultural Captivity* ©2004 Crossway Publishing.

3. Rohr, *Everything Belongs*

Chapter Nine

1. Denise Levertov, *Unaccompanied*, from SANDS OF THE WELL ©1996 by Denise Levertov.
Reprinted by permission of New Directions Publishing Corp.

2. Julian of Norwich

3. Rohr, *Everything Belongs*

4. Pearcey, *Total Truth*

Chapter Ten

1. Anadara Arnold, *Every Little Thing* © 2008 by Anadara Arnold.
2. Os Guinness, *The Call* © 1998, 2003 by Os Guinness.

Morgan James
Speakers Group

www.TheMorganJamesSpeakersGroup.com

We connect Morgan James published
authors with live and online events
and audiences whom will benefit
from their expertise.

Printed in the USA
CPSIA information can be obtained
at www.ICGtesting.com
JSHW060053150824
68134JS00032B/2725

9 781683 502067